Diana Springall

A BRAVE EYE

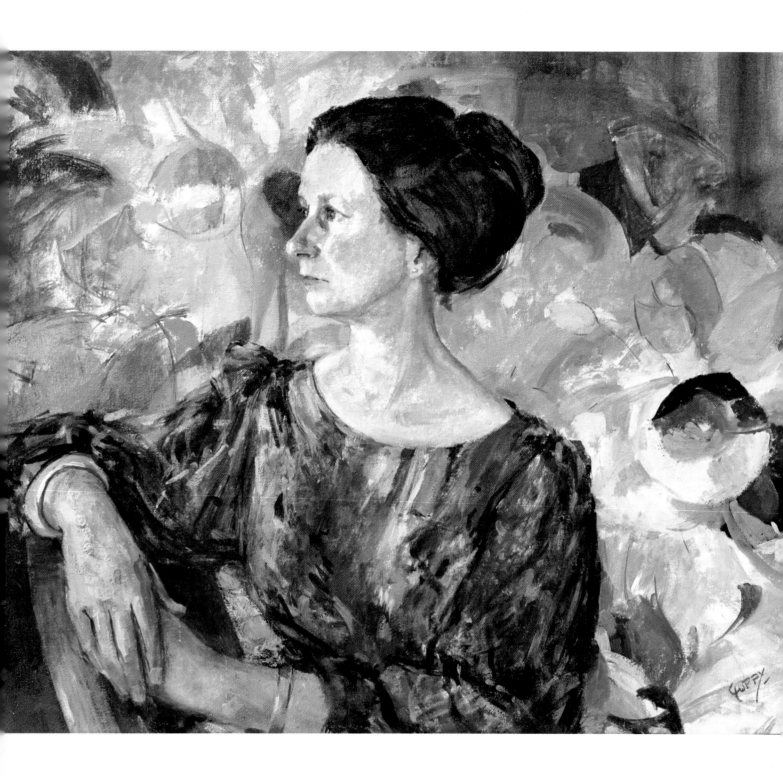

Portrait of Diana Springall, 1988

Nina Guppy b.1934 portrait painter.
Oil painting on canvas 40 x 50 cm.
A gift from the artist on the occasion
of Diana's fiftieth birthday.

Diana Springall

A BRAVE EYE

June Hill

A & C BLACK • LONDON

First published in Great Britain 2011
A&C Black Publishers
36 Soho Square
London W1D 3QY
www.acblack.com

ISBN: 978-14081-47078

A CIP catalogue record for this book is available from the British Library

June Hill has asserted her rights under the Copyright, Design and Patents Act,
1988, to be identified as the author of this work.

Cover design: Sutchinda Rangsi Thompson
Page design: Susan McIntyre
Publisher: Susan James

Typeset in: 11 on 14pt FB Californian

This book is produced using paper that is made from wood grown in managed, sustainable
forests. It is natural, renewable and recyclable. The logging and manufacturing processes
conform to the environmental regulations of the country of origin.

Printed and bound in China

Contents

Elmhurst, 2010

Low relief panel in felt and painted cotton with hand embroidery,
68 x 155cm. Commissioned by John and June Robson. Photo by Simon Olley

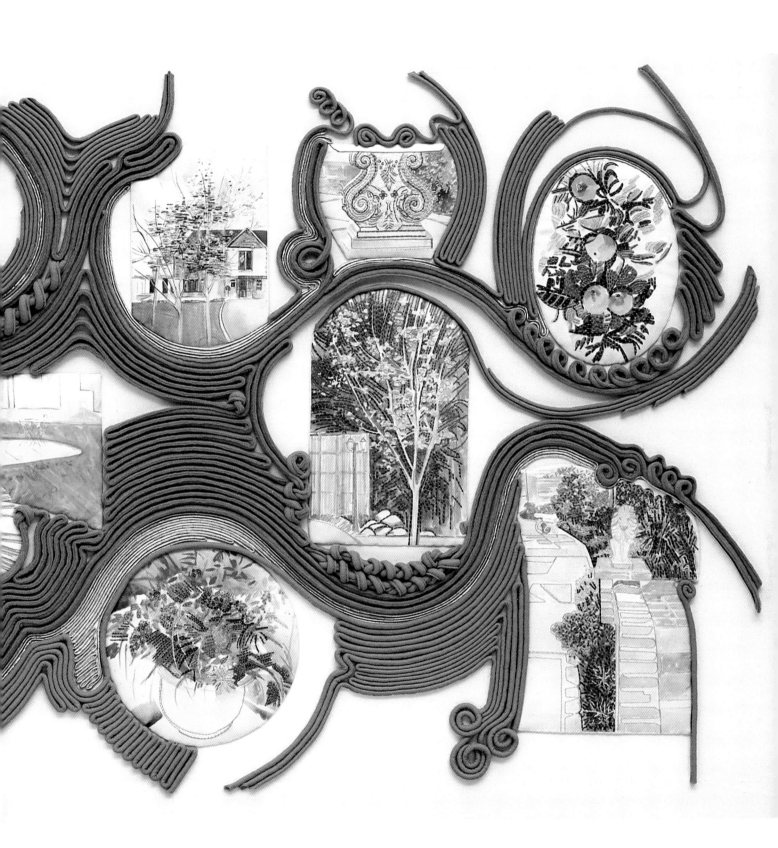

Acknowledgements

The artist wishes to acknowledge the support of her sons Richard and Lawrence.

The author would like to thank Diana Springall for the opportunity to write this monograph and for generously sharing herself and her home. Thanks also to Jan Beaney, Reverend Mandy Carr, Caren Garfen, Professor Anne Morrell, Andrew Salmon and Pat Wright for their contributions to the text. Finally, thanks to Dr Jessica Hemmings for permission to quote from her essay; Edward Lucie-Smith and Ann Hechle for their agreement to include the poem; to Professor Lesley Millar and Hilary Bower for their comments on the draft text and to Susan James for making the book possible.

Ode to a Mariner, 2002

Three million year old Encope encircled with couching in silk and gold threads on a silk ground. Made as a gift for the artist's sea-faring brother to display on the bulkhead of his yacht. Photo by Diana Springall

Introduction

In September 2009 I received an email from Diana Springall. The words in the subject field read 'A little book'. Diana was looking for an author to write a small paperback about her life. She wondered if this might be of interest to me. The email then explained how the project had been initiated by James Morton-Robertson, a neighbour and film-maker, who was encouraging Diana to document her practise. Having initially resisted the idea because 'there was not much to film', she had now relented and sanctioned the production of a DVD and related publication. James would make the film. Could we speak to toss around thoughts about the book and see if this was something I might consider?

Having worked as a curator of textiles since the 1980s, I had been aware of Diana's name for some time. It is one that has long been associated with contemporary textile practise. Reflecting on her email, I realised that whilst I knew the name, I did not know the person nor the full extent of her work. So, before coming to any decision, we agreed to meet up to discuss the project further and find out more about one another.

That meeting took place two months later at the International Conference Centre in Harrogate where we were both involved in exhibitions at the Knitting and Stitching Show. As we sat side-by-side on one of our exhibition stands - part invigilating, part conversing - Diana shared her vision for the biography. It was to be a rounding up of her life. The key point to convey was the importance of persevering and, whatever the final content, it must be modest.

It is hard not to warm to someone who commissions a biography with the aim that it encourages others to 'stick at' their practise and a desire that it be written with humility. Diana's brief was almost a subversion of that which might be expected of a self-generated biography. It revealed much about both her character and her practise. I was intrigued: I wanted to learn more about this person and all she had done. We were on our way.

As I researched Diana's life over the next nine months, I began to absorb the extent of her contribution to the field. A quietly pervasive presence, she has never been afraid to step out beyond current boundaries to promote textiles and, in

particular, embroidery. Unusual in creating large-scale works from an early point in her career, she has taken that capacity to think big into her work as a teacher, curator and advocate. Diana would hesitate to say this herself, but during her five decades of practise, she has been responsible for a series of aspirational projects that have exposed the medium to new audiences.

Her life is a testimony to her belief in the value of stitch as both an artform and a pleasurable recreation. Inclusive yet independently minded, she refuses to be swayed by fashions or whims and remains quintessentially herself. Acutely aware that she does not fit easily within what she describes as the 'acceptable "art" pocket'[i], she is nonetheless committed to encouraging others who do and whose work she respects as a fellow practitioner. Diana is a surprising person, and one of the lessons her life imparts is the inherent danger of preconceptions – whether they be about people, cultures or disciplines.

Every field of endeavour has its roll-call of influential figures. The names vary from discipline to discipline, but the context in which they exist remains the same. These are the people who have helped make a field what it is today: people whose practise has presaged the present or presented a future.

The contribution made by many of these figures may be unknown outside their particular field. Even within their chosen discipline, the extent of a person's influence will not always be fully acknowledged. For those who know their work, however, these names have a significance that extends far beyond personal identity. They have become a statement of practise. These are people whose work requires attention. At the sound and sight of their names, ears prick up and eyes focus. We listen to what they have to say. We look to see what they have done. And we do this because there is something here to learn: something of advantage not just to ourselves, but to our understanding of that with which we are engaged.

This is the story of one person: Diana Springall. It is the story of her life and practise and how the one has influenced the other. This is also the story of textiles as an artform and how the discipline has developed within, and through, one lifetime. This story is our story.

June Hill

Poem by Edward Lucie-Smith written for the 1976 V&A craft event in which Diana was one of seven exhibitors. Lucie-Smith wrote poems in response to each participant and their medium. The set was reproduced for sale with calligraphy by Ann Hechle and published by the Victoria & Albert Museum Press.

[i] Artist's personal correspondence, 16 August 1999

the trout stitches the ripple.

the plough embroiders the field.

everywhere I look there is & making

Leaves make a wood
Leaves make a wood with their veinwork

all

from a plaiting of twisting growing branches

ALL THINGS

needle moves they are knotted, knitted intricate.

GROW as the

PULL ONE LOOP AND THE

GROW

NEEDLE MOVES

WORLD UNRAVELS

ACTIVE THIS HAND + PATIENT THE MIND THAT PLANS THE FATE OF THE THREAD + THAT LEADS IT BY ONE ROAD + THEN BY ANOTHER +

Stitchery which bound Gulliver

THERE IS AN OLD MAGIC HERE

Bonds for the imagination

SOMETHING THAT COMES DOWN TO US

FROM THE FIRE IN THE CAVERN,

FROM THE CLUMSY MOVEMENT

OF THE BONE NEEDLE.

Foreword

The 'continuous present'[i]

I am appropriating and taking some liberties with this familiar Gertrude Stein phrase. I use it not for its conceptual reference to time and space, but as a description of the constancy that shines through in all Diana Springall's work, of her perpetual gifting of inspiration to craft and embroidery.

The art and philosophy of William Morris (in a different manner from Stein), also searches for a language through looking back to beginnings. Indeed many of us acknowledge the legacy of Morris' vision within the Arts and Crafts Movement and the integration of various art forms within our own work. It is a vision which celebrated craftsmanship, bringing the principles of medieval pre-industrial artistry into his practice and thinking. He championed a blurring of divisions between artistic mediums, with craftsmanship sharing the status of other more elevated art forms. It is to some extent a utopian view, one echoed in his theories on social reform and equality. It is a world where each individual holds responsibility for the community, for authenticity and for the integration of art with an appreciation of the natural beauty of life. As such the inside and the outside world and the sense of universality are intrinsic to both his designs and his philosophies.

DIANA, THE HUNTRESS *Courage and selfless determination*

Diana Springall, like Morris, has spent a lifetime determinedly practising and championing the crafts. They share a conviction in the value of making and design, a determination of accomplishment, and a joy in sharing the experience of both.

Diana's subject has become her cause; embroidery as a practice underpinned with the principles of art. She attended Goldsmiths' College, University of London, in the 1950s and studied painting and subsequently embroidery under the tutelage of Constance Howard who with her hair dyed emerald, coached no nonsense sound technique and ruled with a rod of iron. 'They were good artists – painters and, illustrators and sculptors – and we got to a good standard very quickly'.[ii] It was a remarkable period which saw the blossoming and emergent voice of stitch through the resolve of now familiar names alongside Diana, of (to name a few) Professor Anne Morrell, Audrey Walker MBE, Christine Risley and Eirian Short. It was, 'a chance to explore needle and thread as a medium for artistic expression rather than something purely functional. That this opportunity

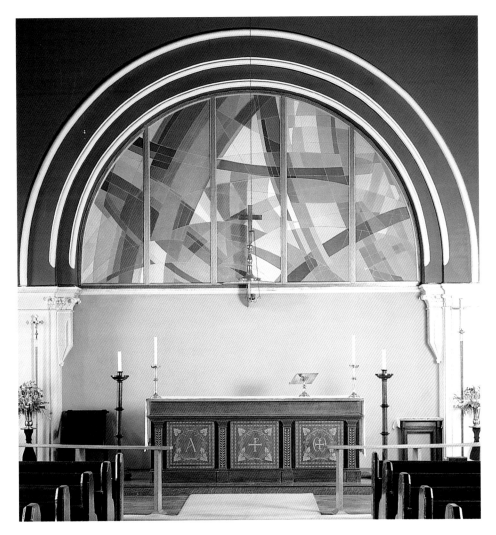

Double-sided Screen, St Anne and All Saints Church, Lambeth, London, 1989

Internal window dividing the church from the first floor chapel, 4.6m wide.

Layers of chiffon are applied with lurex thread by machine. The design is based on the symbols of Alpha and Omega – the beginning and the end. Memorial to the Revd John Colchester. Photo by Dave Hankey

should be based on a knowledge of the theory and practice of both elements – art and stitch – was highly influential.'[iii]

I have heard stories of these times which are richly characterised with these inspired artists and strong individuals. They are voices which have remained constant in their passionate commitment to stitch. These artists made a choice of medium which was deliberate. It was not a secondary choice since they were proven artists, painters and designers whose discovery of stitch excited a passionate understanding of materiality. This was a period which lacked the sometimes more determined split between art and craft of today and Diana's work as a painter and embroiderer was established and collected in both mediums. Her artwork *Graduands* made for the University of Sheffield Library and unveiled in 1988, was described by Sir Hugh Casson as 'an ambitious and impressive work of art – a piece of enlightened patronage.'[iv] Her stitched work *White Line* made in 1972 was purchased by Mrs Rachel Caro sister of the sculptor Anthony Caro.

The emphasis during this period embraced craftsmanship; these artists recognised the illustrative potential of thread and cloth with a status that was distinct and equal to painting. 'In place of simulacra and mimicry is an emerging

appreciation, once more, of specificity: work grounded in, and defined by, a particular time and place.[v] This is a sentiment that Morris and his mentor Ruskin would recognise with their philosophy against imitation and the mixing of styles. These artists established an emphasis on craft that has understood the primacy of material, process and artist rather than the relationship between viewer and artist; 'craft, more than design, has sustained a continuous relationship between maker and material, not diluting this intimacy in favour of a newly pronounced connection between artist or designer as conceptualiser and audience.'[vi] In a post-modernist climate they laid the foundations for us all of a very particular and nevertheless important emerging stitch/embroidery focused textile art.

DIANA, THE MOON *An encompassing vision*

I first met Diana in 1986. I had finished my postgraduate course at Goldsmiths' following a similar path of painting and embroidery. Diana purchased my work *Eve Falling from Grace* from the Embroiderers' Guild show at the RIBA in London. It was a landmark moment which started my career in embroidery. So it was that I found an extraordinary patron and friend. What I did not realise then was her eminence and the breadth of her work in her practice, teaching, lecturing and advocacy. Like Morris her orbit is inclusive and philanthropic. Many can say as I do that she has furthered our careers. Many acknowledge a debt through her teaching and magnanimity. Diana herself explains; 'The teaching of art must, to remain lively, always draw on other subjects for stimulus.'[vii] The post war period was where women championed the arts, as Tanya Harrod describes, 'gendered skills, meant that women seeking careers tended to be pushed into embroidery; an embroidery class led by a powerful woman could create opportunities denied female students in a male dominated sculpture and painting department.'[viii]

What comes through in this volume, so sensitively written by June Hill, is Diana's devotion to her subject through making, authorship, curatorship, and leading roles such as the Chair of the Embroiderers' Guild. She is a campaigner much like the political activists though her politics are altruistic and concerned with embroidery.

I should like to make especial reference to the Diana Springall collection, a personal archive of embroidery put together over four decades from the 1960s. It is a collection of a very particular textile interest with an awareness of wider responsibility which is now acquiring a public dimension. In the tradition of the best private collections it is driven by passion and emotion and formed by instinct and insight. What makes such collections intriguing is the nature and manner of collecting, and the personal relationship of the collector with their acquisitions. Kenneth Clark (the author and art historian) once asked why men collect and decided that it was like asking why we fall in love — the reasons were as random and individual and various. Diana Springall's collection is specific in its intense and single minded focus on stitchery.

Diana's collection has been put together with the same courage and discernment as the artistic investment in each work. The collection is about individuality, the

St Anne and All Saints Church, detail of appliqué. Photos by Dave Hankey

authentic vision of each piece made stronger through its place within a collective group. As such the collection substantiates a period in history which stands apart from fashion or prevailing trends. The Diana Springall collection is as a 'testament to a diverse tradition of work with needle and thread that is often omitted from mainstream discussion of visual culture.' [ix]

As Diana describes; 'The main emphasis is, however, on the enormous value of original thought, however simple the initial ideas, and to stress and prove that originality can be achieved right from the beginning.'[x]

On reflection and with the benefit of time we can see this enlightened custodianship as with all Diana Springall's gifts, leaves us a powerful legacy and an ongoing and continuous present which can change attitudes and inform future practice. To appropriate the words of William Morris, Diana gives us in the widest sense an 'education through [her quiet] revolution'.

Alice Kettle

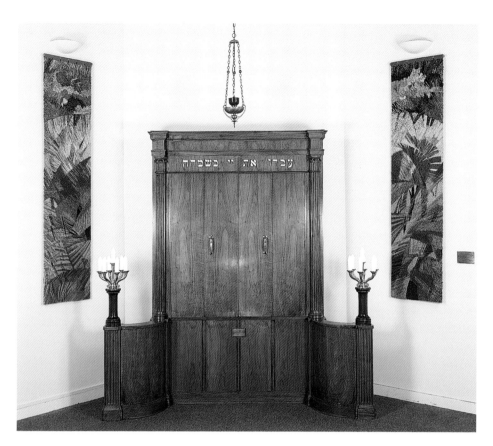

Pair of Hangings, West Central Synagogue, London, 1998

The hangings depict Exodus 25 verse 20

'And the cherubims shall stretch forth their wings and on high covering the mercy seat with their wings and their faces shall look one to another toward the mercy seat shall the faces of cherubims be.'

'Each time I go [to the synagogue] I admire your beautiful tapestry. It adds so much to the space.' (Postcard from Simon Tabak, November 2010)

RIGHT Completed work, 201 x 45cm

Photos by Dave Hankey

i 'Continuous present is one thing and beginning again and again is another thing. These are both things. And then there is using everything. This brings us again to composition this the using everything. The using everything brings us to composition and to this composition. A continuous present and using everything and beginning again.'
Composition as Explanation Gertrude Stein. First delivered by the author as a lecture at Cambridge and Oxford, this essay was first published by the Hogarth Press in London in 1926 and revived in the volume called *What Are Masterpieces*.

ii *The Crafts in Britain in the 20th Century*, Yale University Press New Haven and London 1999 Chapter 8 p295, Tanya Harrod

iii *Diana Springall*, Chapter 2 p34, June Hill

iv University of Sheffield Annual Report 1988/9, quoted *Diana Springall* Chapter 2 p39

v *An Embroiderer's Eye: The Diana Springall Collection* was published in 2009 to accompany an exhibition of the Diana Springall collection at Macclesfield Silk Museum. It includes details of the collection and a contextual essay by Dr Jessica Hemmings.

vi *craft + design enquiry* – www.craftaustralia.org.au/cde Ravetz, A. and Webb, J., 2009, *Migratory Practices: introduction to an impossible place?*,craft + design enquiry, vol. 1

vii Diana Springall, quote from *Sea Waves*: a teaching project developed during her Art Teachers Certificate, Goldsmiths' 1960-1, Chapter 3 p50

viii *The Crafts in Britain in the 20th Century*, Yale University Press New Haven and London 1999 Chapter 8 p293, Tanya Harrod

ix *The Times*, Nov 6 2007, Rachel Campbell-Johnson, 'The secrets of successful art collectors'

x *Canvas Embroidery* 1969, BT Batsford, Diana Springall text on slipcover quoted in Chapter 4 p60

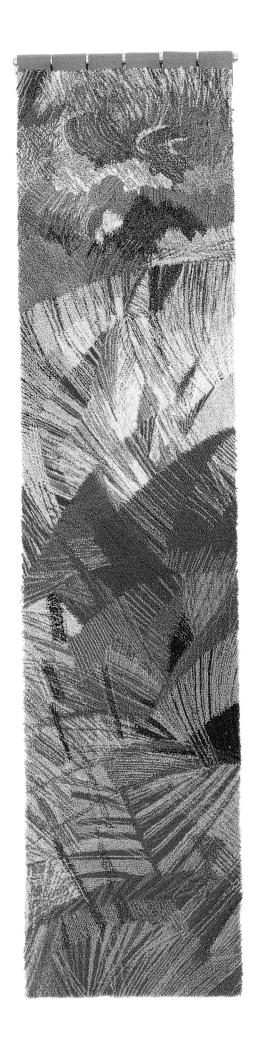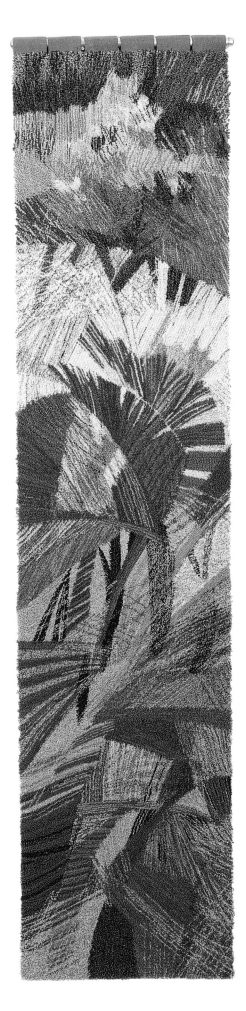

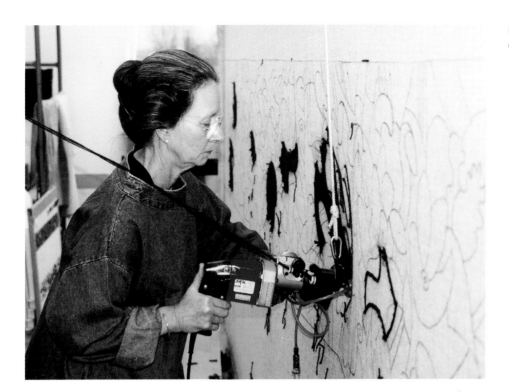

Diana at work with her Hoffman carpet gun

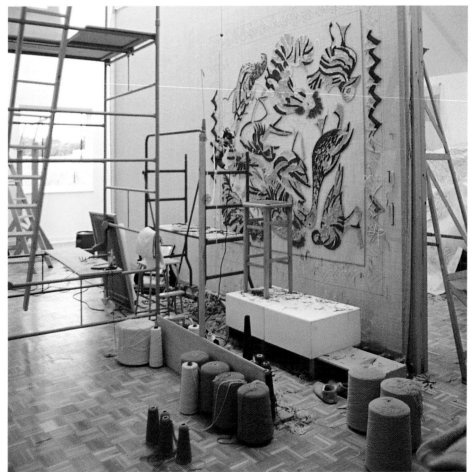

Hens, Ducks, Geese, 1993.

LEFT Carpet under construction on frame, from the back. Photo by Dave Hankey

RIGHT *Hens, Ducks, Geese* 1993 Completed carpet 320cm sq. 16mm pile. Handtufted. Photo by Dave Hankey

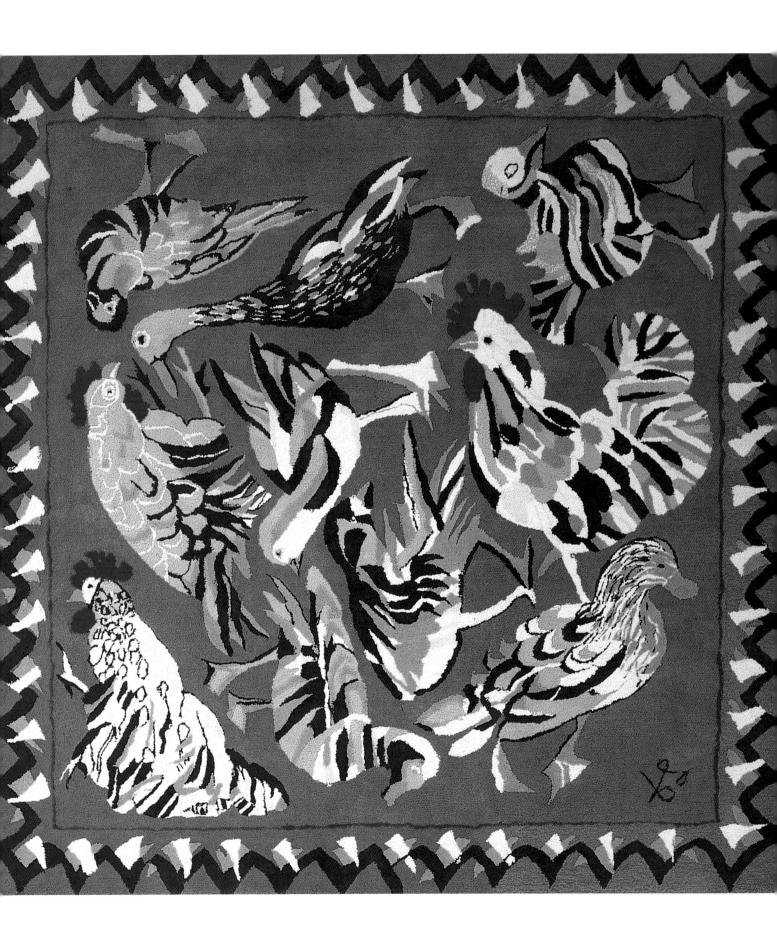

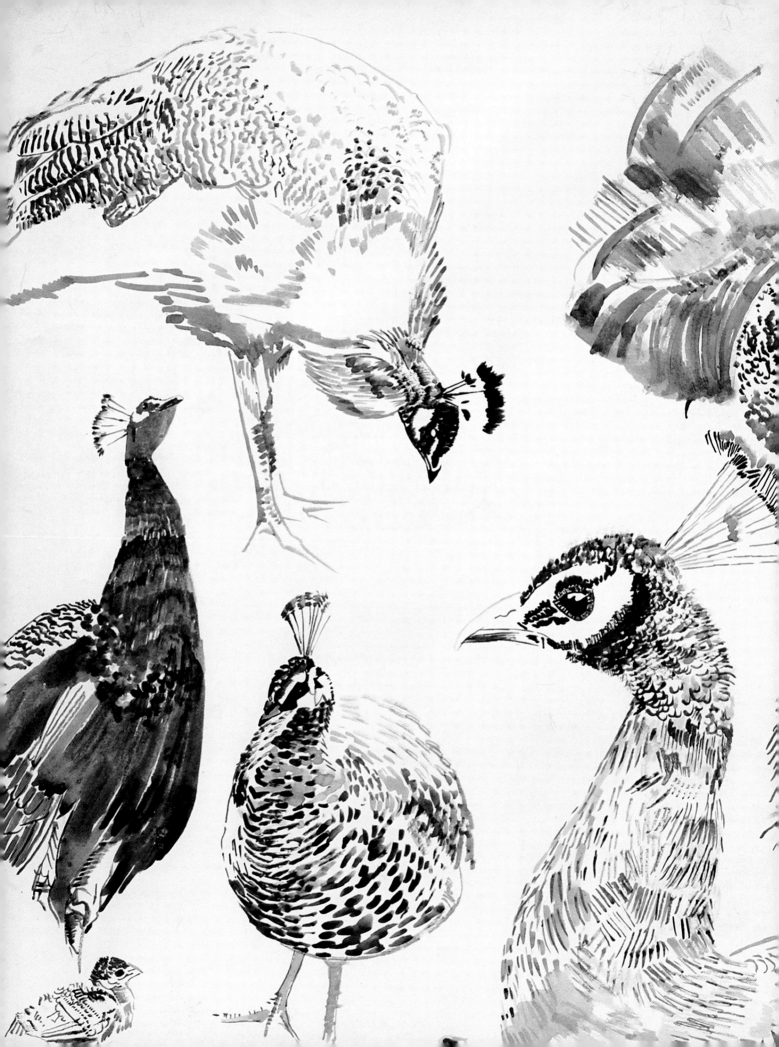

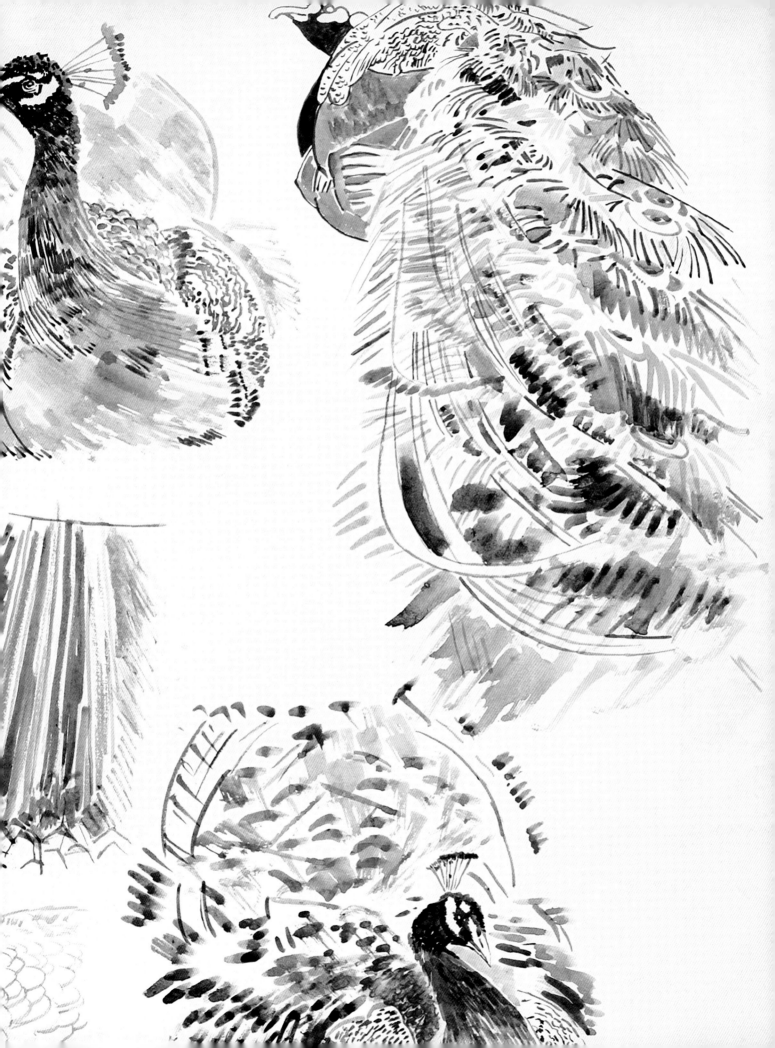

1

Early Years

'I can't ever remember not sewing.' [i]

Diana Springall was born in India on September 16th 1938. That day is a lifetime away now – a little beyond the three score years and ten. So much has changed in the seven decades since then; indeed much changed during her childhood. Twelve days after Diana's birth, Neville Chamberlain returned to England from Germany with the Munich Agreement. A year later, there was war. India remained a vital part of Britain's empire for a while longer. Delhi, the city where the family lived, being a strategic outpost for the war in the Far East. Then came partition in 1947, and their journey by ship to England.

Those early years in India, whilst not long, were formative for Diana. They helped shape both her character and her creative practice. They are part of the person she has become. So, it is in India where this story begins – India, the place where Diana first learnt to stitch and to paint, and to persevere when things are not easy.

Diana was born an Alexander, not a Springall. The first nine years of her life were spent in Delhi, the city where her father, Gordon Alexander, served as Under Secretary of State in the Indian Civil Service. It was an onerous post and one he held during a period of exceptional tension. The Second World War and campaign for independence both taking place during his term of office.

Domestic life was typically colonial. Diana and her brother, Brian, grew up seeing little of their parents. Sundays were family days, but the remainder of the week was spent in the care of a governess and an ayah. [ii] It was a privileged and an isolating lifestyle. There was no school and little opportunity to engage with others of their own age. The days could be long and tedious. Consequently, the children learned to amuse themselves. 'We had oodles of time to think and play,' recalls Diana. 'I remember doing still lives at the kitchen table – and sewing.' [iii]

Drawing and painting were much loved activities, but it was the practice of stitch that seemed to permeate the household. Every day their dhurzi [iv] would perform some chore or other at his sewing machine. 'It was all practical sewing, but he was very skilled.' Then there was Diana's mother, Stella, an exceptional needlewoman who embroidered linen for the home and was involved in sewing

PAGES 20-21

Peacock sketches

Gouache. Photo by Simon Olley

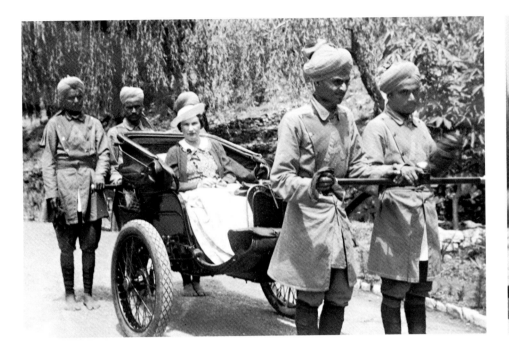

LEFT Mother in a rickshaw in Simla, 1936

ABOVE *Dhurzi busy sewing on the family verandah in Delhi, 1938*

circles during the war. 'It was a great treat for me to be allowed to join the ladies work parties preparing bandages for the army hospitals. That's where I learned herringbone stitch.'

This was sewing as function: something done to gainfully occupy time; to decorate the home or meet a particular need. 'I wouldn't have learned to sew and knit if I hadn't had a boring childhood. I had dextrous skills beyond my years, but it was totally non-creative.' There is nothing pejorative in this statement; it is simply a matter of fact. Diana has always valued the place of needlework as a practical craft, recognising its importance in her own life. A strong advocate for embroidery as an art form, she is equally convinced of the merits of encouraging people to simply stitch. 'There would be so much unhappiness, loneliness and insanity without it.'ᵛ

Diana has never forgotten the pleasure stitching pre-printed designs brought to her childhood. It is an experience she has brought to others through a lesser-known aspect of her work – that of designing embroidery kits. 'I'm a great believer in kits because that's where I started. You can begin with a kit and it can take you elsewhere. Kits for cards have been a big part of my career. In the late 1980s I used to design card kits that were attached to the front cover of the Christmas and Easter editions of *Needlecraft* magazine. They would need 100,000-150,000 for each edition. I would make the design, then use a punching machine to transpose the pattern as holes onto the cards, sort all the threads and provide the instructions before delivering to the packager. Around the same time, I also had an order from the National Trust to make 5,000 gift packs for their shops. I used to employ a small team of people in the village to help operate the punching machine – we did a thousand cards an hour. I would make prototype cards to show what the finished design was like. It is quite therapeutic making the samples – you just go on stitching, just do another – it's quite compulsive.'

Sketch of hydrangea, gouache, 1992. Photo by Simon Olley

Prototype card inspired by hydrangea paintings: Berlin star and cross stitches in Retours a Broder and stranded cotton. Photo by Diana Springall

Blank card punched for hydrangea design. Made using a machine Diana purchased from Sloper's, a specialist company involved in perforating stamps, including the Penny Black. 1992. Photo by Diana Springall

Canvas work embroidery with pearls mounted in card with pencil drawing of flower petals, 1995. Photo by Diana Springall

Card inspired by hydrangea paintings: Berlin stars and straight stitches in Retours a Broder and single strand cotton, with pearl and coral beads, 1995. Photo by Diana Springall

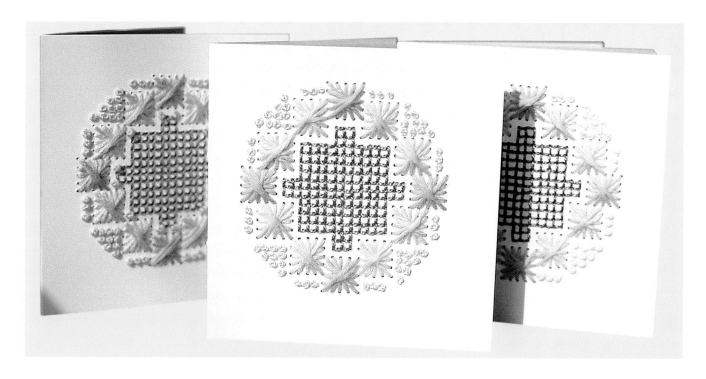

Card inspired by hydrangea paintings: Berlin stars, French knots and straight stitches in Retours a Broder and stranded cottons, 1993. Photo by Diana Springall

Finished card produced for Christmas edition of *Needlecraft* magazine, 1996. Photo by Diana Springall

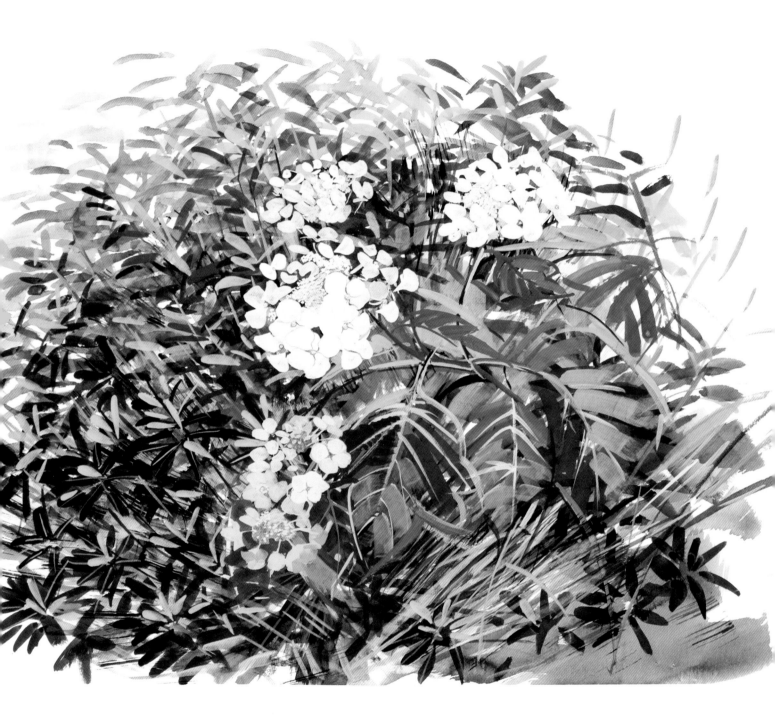

Hydrangea painting, gouache, 1992. 39 x 51 cm.
Photo by Simon Olley

Creating a design that people would enjoy working was something Diana found rewarding. Drawing people into the craft with the possibility that they might decide to take it a little further, was a bonus.

Does it concern Diana if someone prefers to work from a kit rather than make an individual design? 'If it makes them happy, why make them move on?'[vi] It is a profoundly realistic response. Diana knows from experience that it is entirely possible to 'move on' from stitching kits to practise creatively. She has done so herself and has devoted much of her career to helping others do exactly the same. She is not denying that can happen, nor her desire that this might take place. No, this is an acknowledgement of something else. This is a recognition that stitch itself is of value; it may lead to other places, but if it does nothing other than bring pleasure to the place where we find ourselves, then that itself is sufficient.

'The most wonderful aspect of embroidery, when practised by those who can take it to the highest level, is its status as both an art and a craft. In the hands of some, who adopt it for leisure, it may remain a craft; for others who choose to adopt it in search of peace, courage and so many other aspirations, it is often therapeutic and constructive. Above all, in Britain, embroidery is a subject unique in bringing professionals and amateurs together as equals.'[vii]

THE UK AND SCHOOL

When Diana's family sailed to the UK in 1947, they left a newly independent nation and arrived in an austere Britain that was experiencing its worst winter in decades. The transition from colonial life was not easy. 'After being treated royally, we had to struggle for everything, including sheets. Mother contracted pneumonia. I can remember practising smiling – "it's important to be happy" – I would say.'

As their parents sought a new posting overseas, the children were sent to boarding school in Scotland where the winter seemed even colder. Family life was decidedly warmer, however, as Diana and her brother were able to spend holidays at the Edinburgh home of their great aunt and grandfather. This was another house filled with needlework. 'Everything was embroidered – sheets, hankies, tablecloths.' In contrast to the emotional detachment of their parental home, this was 'a haven of love and comfort'[viii]. 'The greatest influence on being happy was my great aunt and grandfather – they always sent us back to school with a book of postage stamps so that we could write and trotted up for our exeats[ix].' From her parents Diana learned independence. 'At the end of the day you're on your own, you're answerable only to you, and that's what a tough upbringing gives you.' From her extended family, she came to know the value of a warm and caring environment – something she would subsequently create herself in the home she was to make at Oast Cottage.

Sketch of hydrangea, gouache, 1992. Photo by Simon Olley

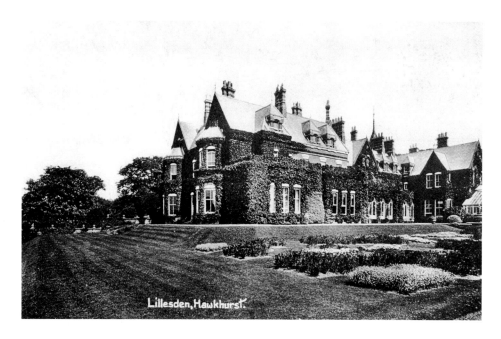

Lillesden, Hawkhurst.

Lillesden School for Girls, Hawkhurst, 1950

Two years after the move to Scotland, Diana's parents settled in Kent and their children were relocated to schools nearby. Now a boarder at Lillesden School in Hawkshurst, Diana continued to stitch. 'I would endlessly knit and embroider transferred linen at school. My mother always said I cost her too much in linen.'

The seven years Diana spent at Lillesden were enjoyable and fruitful. Encouraged by her art teacher, Nina Guppy, Diana began to develop her creative skills. A pivotal figure in Diana's life, Guppy was an inspirational tutor and it was she who guided her young student towards a career in art. 'I wasn't very good at school but [Nina] said I should go to art college, so she must have detected something.'

It was not an option favoured by Diana's father who was concerned that his daughter would descend into a life of Bohemianism. Diana, however, was not to be deterred. She applied to five art schools, was accepted by all and chose to go to the nearest: Goldsmiths' College School of Art in New Cross, London. The course she elected to take was the National Diploma of Design (NDD) in Painting.

[i] *Richmond News Leader*, April 23 1982

[ii] An Indian nursemaid

[iii] All quotes by Diana Springall are from interviews with the author unless attributed otherwise

[iv] A man-servant employed to do all household sewing. Also spelled durzi

[v] *Richmond News Leader*, April 23 1982

[vi] As above

[vii] *Inspired to Stitch*, introduction p11

[viii] *The Well, Kemsing Village Magazine*, Autumn 2007

[ix] An exeat is a leave of absence from school or college

RIGHT Selection of punched card designs. French knots and straight stitches in stranded cottons, metallic threads and cords, 55cm sq., 1995. Photo by Diana Springall

2

Goldsmiths'

'I'm a painter. I always start with painting – whatever I do starts there.'

In 1954, Goldsmiths' became the first UK college to offer an NDD in Embroidery. It was a significant development: embroidery now being presented as a subject for study within the context of a fine art programme and at the same high academic standard. Even after sixty years of creative textile practice, this still seems an enlightened and exciting policy: a chance to explore needle and thread as a medium for artistic expression rather than something purely functional. That this opportunity should be based on a knowledge of the theory and practice of both elements – art and stitch – was highly influential. A marker had been set down. By the time Diana began her studies at the college two years later, Goldsmiths' embroidery course was already established as a programme of substance.

Much as Diana loved stitch, it was as a painter that she enrolled at Goldsmiths'. Perhaps it was inevitable that these two fascinations would coalesce at some stage during her training. Inevitable or not, it is precisely what occurred, and there could have been no more appropriate college than Goldsmiths' for this coming together to take place.

Every NDD course was divided into two parts – the Intermediate and the NDD. Each section lasted two years and was co-dependent: students had to pass their Intermediate examination in order to proceed to the final NDD. Whilst this format was generic, the content of each course varied from college to college.

At Goldsmiths', the dominant discipline of the Intermediate course was drawing. Every form of the subject, including life drawing, was explored in the day classes students attended. These sessions was complemented by others held on weekday evenings and Saturday mornings which introduced students to a range of supplementary subjects that included: printmaking, perspective, history of art, lettering and one optional craft – either pottery or embroidery. Students were examined on these subjects at the end of their second year. Those who passed were awarded their Intermediate and could continue towards their NDD. From here on, they would specialise in either a single discipline or a main and additional subject. Diana would concentrate on painting at this latter stage. For those who had chosen differently, the specialism could be sculpture, or illustration, or embroidery.

PAGES 32–33
On my Window Sill, 1990
Gouache painting, 53 x 74 cm. Photo by Simon Olley

RIGHT *Boats at Horta*, 1993
Folding screen, machine appliqué of Viyella fabrics, 1.50 x 1.60 metres. Photo by Dave Hankey

'My work is very much based on a fine art approach – I trained in art but I have absolutely nothing against the "craft" label, as I do consider myself as a craftsman. My screens, for example, may appeal to someone because they have a use, as well as being a work of art...I am an embroiderer – I don't dress it up in fancy words, even though I think it is a great shame that fine art galleries won't show embroidery as works of art.' (Sevenoaks Chronicle Feb 6 1987)

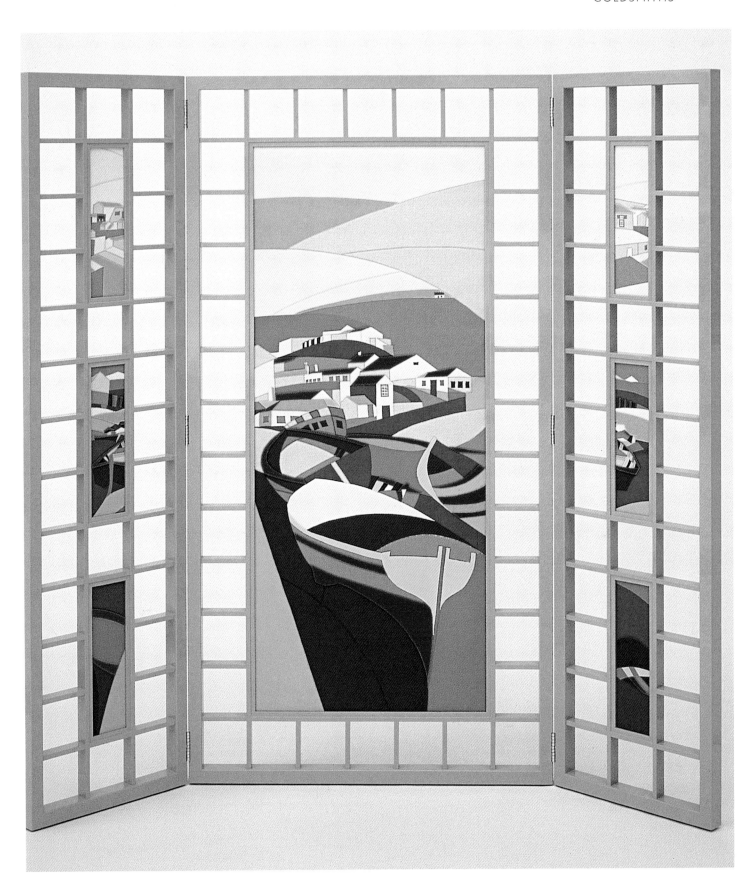

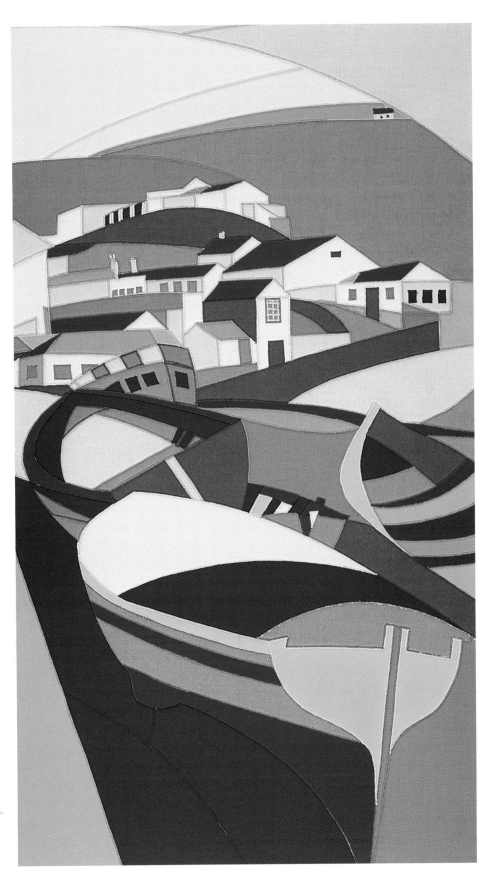

Boats at Horta, 1993

LEFT Gouache sketch made whilst on holiday in the Azores. Photo by Diana Springall

RIGHT Central panel detail. Photo by Dave Hankey

Diana's first year at Goldsmiths' did not go easily. The course was not at issue; it was her health that was to prove the complication. Having begun her course at the start of the Autumn term in 1956, Diana subsequently contracted polio. The family doctor's swift diagnosis proved critical. It ensured Diana received treatment at an early stage and prevented any permanent disability. Never one to linger unnecessarily, Diana returned to Goldsmiths' as soon as she had recovered and was able to resume her studies without any significant disadvantage.

The practice of drawing and painting consumed much of Diana's energies throughout her NDD studies. There was a strong emphasis on observational, rather than expressive, drawing and a further emphasis on colour. The study of extant artworks was seen as integral to their learning and students were encouraged to visit the Tate, the National Gallery, the Royal Academy and the V&A to view and analyse their exhibits. For Diana, these visits marked the beginning of a life-long involvement with the galleries and their collections.[i] The study of historic practice – art and craft – is something she continues to value, finding it a source of pleasure and inspiration. It is a form of observation she has long practised herself, and one she has encouraged in others through her teaching and publications.

PAINTING AND EMBROIDERY

Painting – and the understanding she gained of the medium at Goldsmiths' – remains central to Diana's practice. All her works begin as some form of painting. Sometimes this will be a study for a specific design. More frequently the painting will be an informal record of something seen. 'It's my bank of colours – flowers, landscapes. It doesn't necessarily translate into what I sew, but it's where I start.'

The natural environment is an enduring source of inspiration. That first memory, we recall, was of Diana sitting at the nursery table in India painting a bowl of fruit. She still paints that which is around her: the garden; a piece of malachite; the grain of a tree; the land ripe for harvest and the same land covered in snow. Describing herself as a colourist with a fascination for line, it is beauty to which she is drawn and on which she focuses. This is not a denial of the harsh or uncomfortable aspects of life, rather it is a deliberate decision to dwell on that which is positive and sustaining

Her drawing skills, described as having a 'draughtsman's clarity',[ii] are equally important to her practice. 'I learned to scale up at Goldsmiths'. It wasn't something that was taught formally, it just happened. Betty Swanwick[iii] – who was Head of Illustration – used to produce exquisite miniature illustrations for the College Christmas Ball. She would casually drift into the Painting School with these drawings and ask one of us to enlarge the illustrations to an enormous size. I recall doing one and it took most of the term.'

That a student could spend virtually a whole term scaling up their tutor's illustration would, today, be a matter for approbation. For Diana, however, it was a valuable exercise that gave her a skill – and a form of perception – she has used repeatedly when designing site-specific commissions. 'The University in Sheffield were looking to commission a work of art for their library and I was invited to

respond. They had envisaged a small picture for the wall, but I said, "Can't I fill it?" The room needed a large piece and I was confident that I could work to that scale. People say, but you're so small, why don't you work to your size. It seemed so natural to fill a wall.' That wall was 12 metres long and 2.4 metres high. The piece she produced, *Graduands*, filled the whole section. At its unveiling in 1988, it was described by Sir Hugh Casson as 'an ambitious and impressive work of art – a piece of enlightened patronage.'[iv]

Ultimately, the embroidery course proved too enticing for Diana and she began to supplement her full-time fine art studies with night-classes on stitch. With barely one hundred students in the school and only six full-timers in each department – the majority of students being part-time – the night classes at Goldsmiths' were both popular and influential. An extension of the day-time NDD course, the evening classes enabled people to study who would not otherwise have been able to do so. Diana was just one of many who gained their first experience of creative textiles at the classes Constance Howard,[v] Christine Risley and Eirian Short led in the evenings at Goldsmiths'.

Diana was fortunate in having already experienced some of the embroidery teaching during her days at the College. 'I used to wander in to other departments to see what others were doing. You could do that then. Then later I joined the evening embroidery classes. One of the early pieces I made – *Head of a Girl* – was loaned for Constance Howard's retirement exhibition in 1975. Someone who saw it remarked "Aren't you lucky to own a Constance Howard"...they didn't realise it was my work. That was how closely we followed her teaching.'

The classes were disciplined and tightly structured. 'Constance was always Mrs Parker, that's as informal as it got.' Materials and stitches, whilst used creatively, were strictly regulated. 'There was always a right fabric and the correct stitch for what you were doing. I used to collect fabric scraps from the dustbins in Soho where the tailors were. I never had to buy any – always had enough. It was something I continued to do in my early years as a teacher in order to have sufficient material for school. It's not something you could do today.'

Whilst those teaching methods may now seem proscriptive, the concern to combine stitch and art practice was both innovative and influential. The significance of this approach for the emerging field of textiles, is something Diana has valued and readily acknowledged throughout her career. In the introduction to *Inspired to Stitch* published nearly half a century later, she would write:

'[This book] is about artists who have become committed exponents of the use of needle and thread and of the skill in raising this craft to an art form. It is no accident that they are all, without exception, the result of an art school system that founded all material skills on the principles of art... This is a book about the significant and very different direction that embroidery took following the end of the Second World War. The main reason for this being that from 1945, its inspiration and development was art school led. The momentous year was 1954, when embroidery first became the subject of a formal qualification, the National Diploma in Design; alongside Painting, Sculpture and Illustration.'

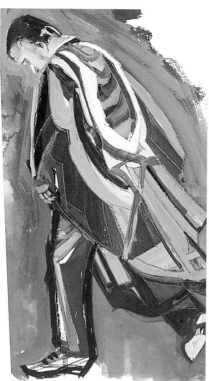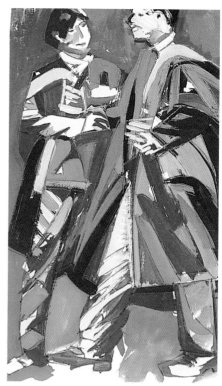

Some of the gouache sketches of students on Graduation Day. Photos by Diana Springall

Graduands, 1988

Wall panel, University of Sheffield Library

'Where do you begin when you are offered a space 12 metres long by 2.4 metres high with the freedom to choose your own subject? I was given a tight budget and 18 months to complete. The design represents students from the 14 faculties of the university. For my starting point, I attended the degree ceremony, sketched and took photographs of the students in their academic robes. Images were then scaled up to 2.5 metres, and their shapes transferred to cloth using eleven different shades of brown from darkest earth to tinges of pink which were applied by machine stitching to the backing. The panel was made in 7 sections joined by long tubes of the different coloured silks that represent each faculty.'

RIGHT Assembly of the panel at the University, December 1984. Librarian Michael Hannon and technician Reg Bishop. Photo by Diana Springall

OVERLEAF The finished panel. Photo by Dave Hankey

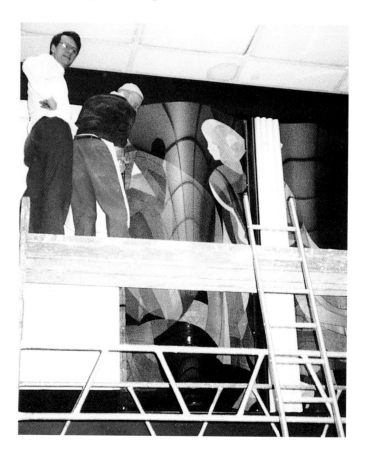

Detail of the machine appliquéd furnishing fabrics and silk tubular structures – the latter denoting faculties – all trapped in polycarbon to give volutes and undulation. Photo by Dave Hankey

Reflecting on her time at Goldsmiths', Diana says, 'I was a terrible plodder, but you can see the lines start here. And the timing was so important – that post-war period and me starting just two years after the introduction of the NDD.'

Diana's experience of that coming together of fine art and textiles – painting and embroidery – was pivotal to her development. 'I found a great challenge in bringing the full scope of my work as an artist to embroidery,'[vi] she explains. It is an approach that has informed all her professional practice.

[i] Diana's NDD thesis presented an analysis of the work of George de la Tour and was inspired by an exhibition of his work at the Royal Academy in 1958 '[That's when] my interest first arose – I was immediately impressed by the ten works there and was determined to locate his other works and delve more deeply into them.

[ii] *Twelve British Embroiderers*, 1984 p107, Elizabeth Benn

[iii] Betty Swanwick RA was Head of Illustration at Goldsmiths' 1948-61

[iv] University of Sheffield Annual Report 1988/9

[v] Constance Howard 1910-2000, was the wife of Harold Parker who was Head of Sculpture at Goldsmiths'

[vi] *Home and Freezer Digest*, June 1988, Carol Bullen

RIGHT *Head of a Girl,* 1958. Photo by Simon Olley

Cotton organdie appliqué with herringbone stitch on cotton ground. Also French knots, couching, feather and chain stitches. 41 x 23 cm

This embroidery by Diana was displayed in the exhibition held at Goldsmiths' in 1975 to mark the retirement of Constance Parker (née Howard). The parallel with Constance's own work illustrates how closely the students adhered to her instructions. Interviewed in the final programme of the BBC series on *Embroidery* Constance commented: 'When we started embroidery at Goldsmiths' in the Fifties it was pure illustration... images were like a vignette – we worked embroidery in the middle with space all around – the image was like a target'

From left: Diana Springall, Constance Howard, Jan Beaney. Image taken from BBC2 *Embroidery* 1980

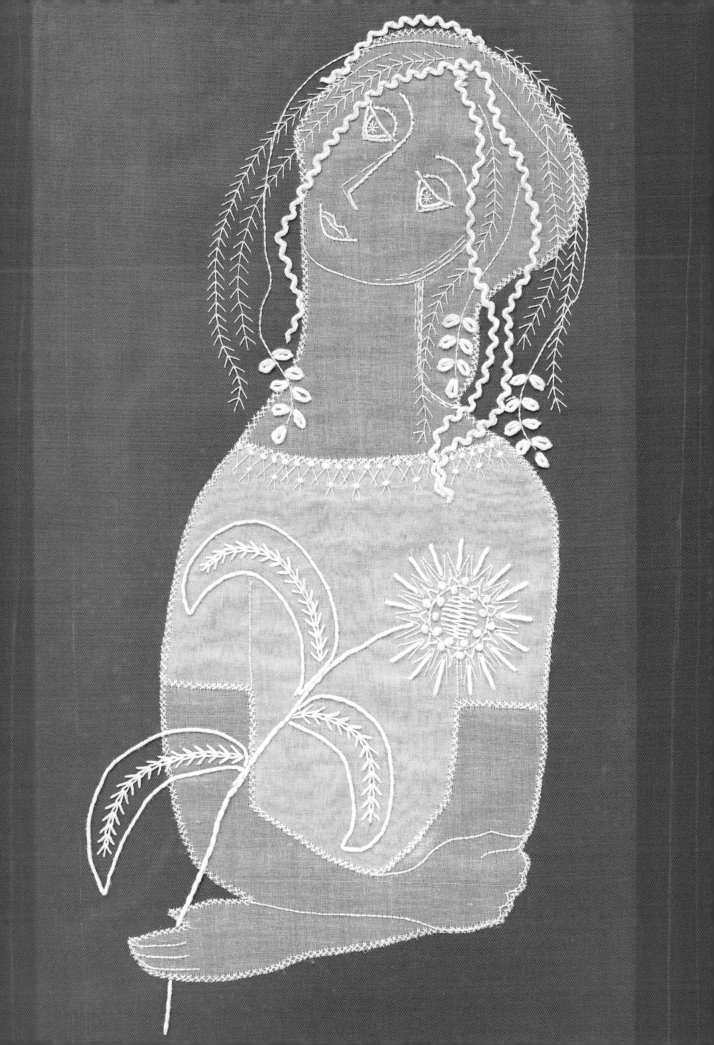

3

Teaching

'I was quite a meticulous teacher...taught history of art as well.'

Awarded her NDD in 1960, Diana decided to stay at Goldsmiths' for a further year in order to take an Art Teachers' Certificate. Her parents were not yet reconciled to their daughter's practise of art and it had been made clear to Diana that she would have to earn a living when her studies were complete. Teaching seemed the right way forward.

It was not a difficult decision to make, for Diana was as fascinated by people as she was by art. 'I wasn't so interested in what I made, but I was in what others did. I'm tremendously interested in people and what triggers their ability to create.' Diana was a natural teacher and art – in paint or stitch – was her preferred subject. The ATC beckoned. When she started the course in the autumn, it was as Mrs Springall, Diana having married Ernest during the summer and set up home in south London.

The ATC was an intensive year-long course that combined study in college with teaching practice and research visits to public collections. Diana's fellow students that year included the painter Alan Cuthbert[i] and Anne Butler (now Anne Morrell). 'Alan was a distinguished colourist and a great mentor to me. Anne came down from Bradford where she'd been studying at art college. We've remained friends ever since.' Anne, who would later become the first Professor of Embroidery at Manchester Metropolitan University, has her own vivid memories of their ATC training.

'I particularly recollect the innovative teaching of Seoniad Robertson[ii] – the writer of two seminal books on art education, who had come to Goldsmiths' from Bretton Hall. She positioned theory and practice at the centre of the course. Students learned both and could then apply each to any materials in what was called Art/Craft/Practice in the art room at a school. Seoniad worked with me to make a kiln in a concrete playground at Christopher Marlow Secondary School off the Old Kent Road so that we could fire pots the children had made. During the year, we also spent some time at the V&A learning about their holdings and how we could use galleries with our school class. That was my introduction to Louisa Pesel and her work which was displayed in the students room.'[iii]

Diana by Alan Cuthbert, 1956
Pencil drawing of Diana knitting during one of the life drawing breaks at Goldsmiths', 25 x 17.5 cm.
Photo by Tim Boyd

OVERLEAF
TOP Pencil drawings of wood shavings, 1972

BELOW Gouache sketches of design ideas for black and white works that became a series, 1972
Photos by Simon Olley

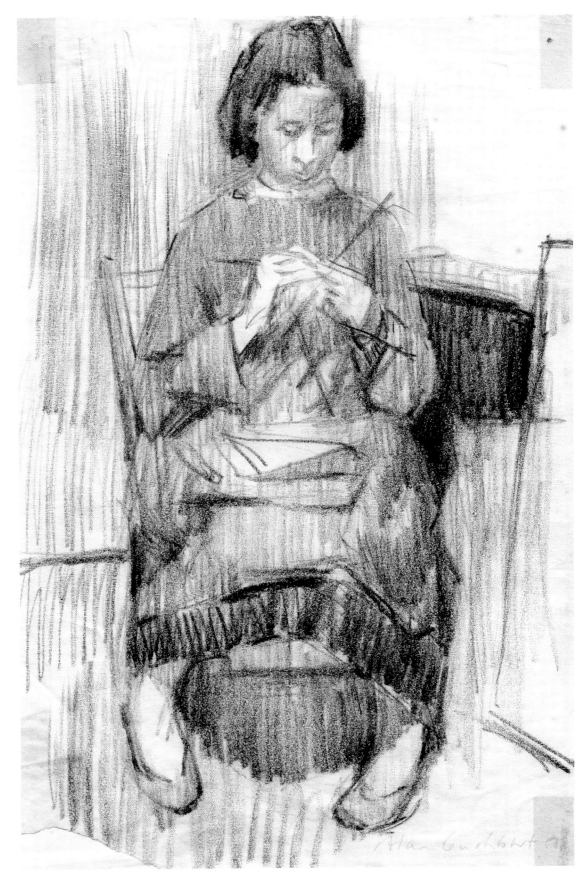

White Line, 1972
Hand stitchery in wool and cotton threads and emulsion paint on black poplin ground, 36 x 92cm.
Collection of Mrs Rachel Caro.
Photo by John Hunnex

As with the NDD, every student taking the ATC had to study a craft. The choice of subject was left to the individual. The only stipulation being that the craft must be different to that practised during their NDD course. Diana decided to study embroidery – the primary discipline she would teach. Whilst she also taught fashion and the history of art in the ensuing years, there was something distinctive that Diana brought to her teaching of embroidery. It was that painters' eye; a love of stitch and her passion for both disciplines. 'That's the way I taught. The concepts are the same whether you're a painter or an embroiderer. Line is the same – it's a sort of heightening of perception.' 'It is fundamental for me...to get to the roots of drawing, seeing and designing and this, I think is my strength as an embroiderer.'[iv]

Her willingness to draw on a diversity of subjects for creative inspiration is another strength. In *Sea Waves* a teaching project devised during her ATC course, Diana wrote: 'The teaching of art must, to remain lively, always draw on other subjects for stimulus.' It was a principle she practised in the classroom and one she shared in her books: aerial photography, microscopic images, historic needlework and found objects all being referenced as potential design sources.[v] It was also an approach that informed her own practise, especially her work to commission. Whilst the natural environment remained a constant stimulus, Diana was equally open to the client related imagery of Japanese calligraphy, electronic circuitry and architecture. The critical factor for Diana was not the derivation of inspiration, but rather that the ideas which emerged were appropriate to the context at hand.

Black Line One, 1972. Panel in black thread and feathers on a Welsh flannel ground, 46 x 20cm. Collection Dr I.A. Bouchier. Photo by John Hunnex

Black Line Two, 1972. Panel worked in hand stitchery, beads and Indian ink on a Welsh flannel ground, 122x 61cm. Collection Mrs Richards. Photo by John Hunnex

On the completion of her training at Goldsmiths', Diana was appointed to the post of Head of Art at West Heath School for Girls in Sevenoaks, Kent. Two years teaching at West Heath were followed by five at Maidstone College of Art where, as a lecturer in the Fashion Department, she taught drawing, history of art and embroidery. Then, in 1968, Diana was appointed to her most significant teaching post: that of Principal Lecturer and Head of Fashion and Textiles at Stockwell College of Education. It was during her time here that Diana established her wider reputation as a tutor and practitioner; and it was here where she was awarded the personal accolade of Recognition status by the University of London.[vi]

An inspiring and thoughtful tutor, Diana was constantly looking for ways to stimulate and encourage her students. She filled her office with material that could foster ideas, even forming a collection of textiles that illustrated specific points. 'I liked to show the students actual things rather than depend purely on books and slides. I felt it was important to study real examples.' Diana's students responded positively to her lead and won numerous awards for their work. Pat Wright who arrived at Stockwell in 1976, recalls her own experience:

'Diana went to great lengths to introduce her students to modern as well as traditional and older work. She invited us to use her fabrics and threads and was always there to advise and encourage us. She was demanding and set high standards, but also incredibly fair. She was able to draw out the best in [us and inspired us] to "put in the hours" because she too was always busy and involved in so much over and above her duties as lecturer at the college. She was generous with her time despite creating her own commissions and moving into her oast house home.

Diana was an inspiring teacher and a caring one too. I had to have the summer term off because of illness and Diana intervened with the other tutors to help me stay on and be accepted into the second year. I remember her visits to hospital bringing with her the tiniest vase and a bunch of violets picked from her garden. On another occasion she came with some very early strawberries which were so welcome after hospital food. Without her encouragement, I know I would not have completed my course. She gave all her students confidence that what they were doing was special and worthwhile. Because of Diana, I began to be myself, rather than be known for being the mother of my children or a service wife.'[vii]

Hard-working, honourable, generous, caring: these are words that recur time and again in conversations about Diana. Professionally, she expects much of herself and much of those with whom she works. Personally, she is always willing to set time aside to help and support those with whom she comes into contact. Diana's ability to combine these two elements – to not lose sight of the person in any situation – is one of her abiding strengths. Talk to anyone who has spent time with her and, at some point or other, they will recall a simple, understated act of thoughtfulness or hospitality; a little thing that meant a great deal. That tough upbringing may have taught Diana that she was on her own, but leaving another person in that place is something she refuses to do herself.

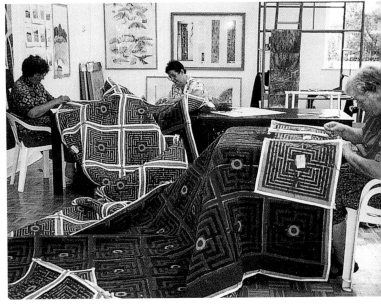

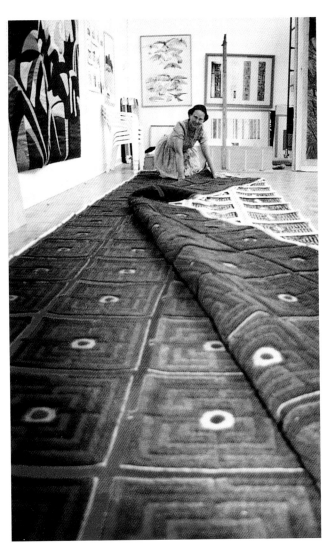

Kemsing Carpet, 1993-1997

Community embroidery project for St Mary's Church, Kemsing, under construction in the artist's studio.

Photos by Diana Springall

[i] Alan Cuthbert 1931-1995 was Vice Principal of Wimbledon School of Art up to his retirement in 1991. He was an active member of the Colour Group of Great Britain (a body founded to foster cooperation between art, design, science and industry) and an abstract painter.

[ii] Seonaid Robertson 1915-2010, obituary *The Guardian* 23/07/2010

[iii] Correspondence with the author, 23 July 2010

[iv] *Twelve British Embroiderers*, 1984 p107, Elizabeth Benn

[v] *Canvas Embroidery*, including bibliography

[vi] A formal acknowledgement of the standard of teaching being provided by an individual or an institution which recognises its appropriateness as a qualification.

[vii] Correspondence with the author, 27 July 2010

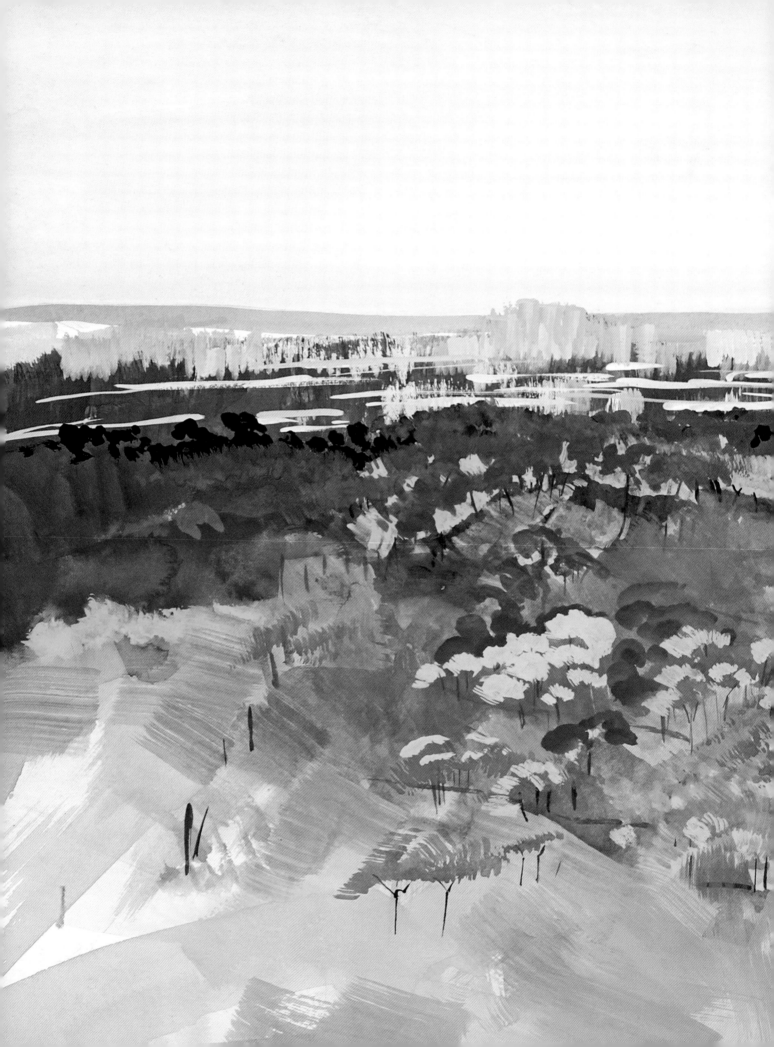

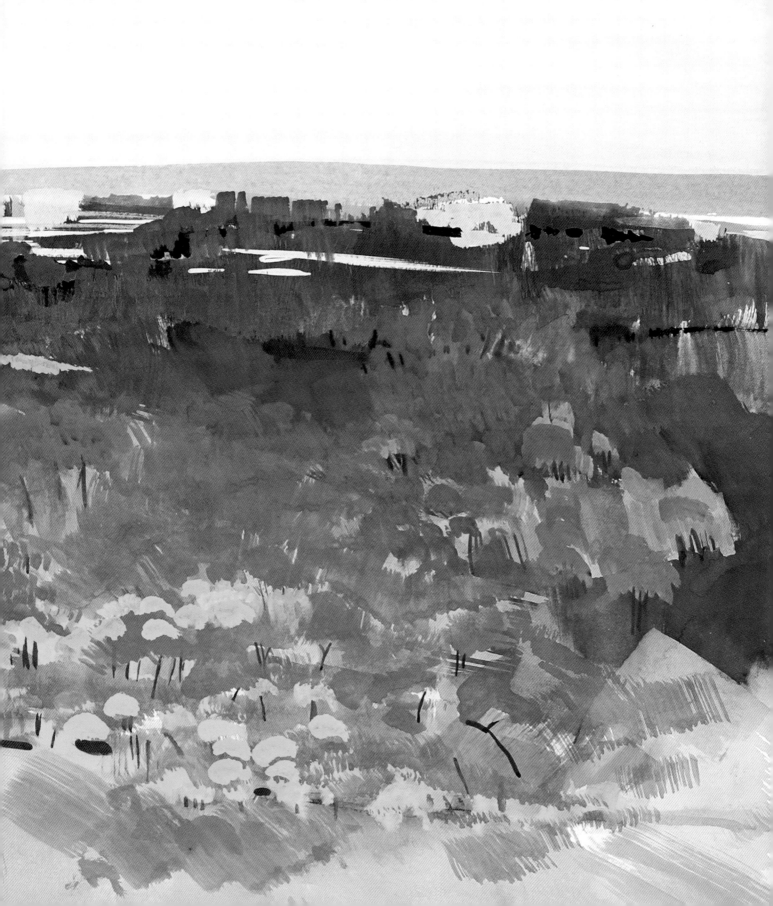

4

Work

'If I had been able to hide away, my work might be more profound. But I couldn't shut myself away. I like people too much.'[i]

As Diana entered her thirties, the pace of life accelerated significantly. By 1969 – the year she published her first book, *Canvas Embroidery* – she was fulfilling multiple roles as the mother of two young sons, a full-time senior lecturer, an external examiner and a freelance tutor.

The level and intensity of these commitments left time for little else, certainly in terms of developing her studio practice. This was to be a recurrent issue for Diana. There was her teaching, her advocacy of embroidery and her family. The need and desire to produce speculative artwork did not sit as high as those other callings on her time. There was also her acknowledgement that this particular way of making was not necessarily her strength, nor the most significant contribution she could make to the field. Interviewed in 2009 by Sue Prichard, Curator of Contemporary Textiles at the V&A, Diana was asked how she would describe her work and position in the field of embroidery. She replied: 'Teacher, lecturer, author and practitioner (designer-maker) and a contributor – hopefully one experienced enough to be enabling and supporting of others.'[ii]

The hierarchy and terminology of that list is telling. Encouraging the work of others and sharing knowledge comes first. Her practice is secondary and is described as that of a designer-maker: a creator of functional rather than experimental art works. As ever with Diana, she is giving an honest appraisal of herself. 'There is no way...my output would be on the same level as great artists. I don't get the time in the studio.'

The studio has never been the main focus for Diana. It is people that capture her attention. 'Some people don't have diversions that call on their time; I am one of those who does.' There are, of course, potential diversions for everyone, but not all are prepared to give those diversions time. Diana is, and it is those very diversions that form a major part of her life. Family and friends, neighbours, her local community and the textile fraternity are all 'things that have to be slotted into life, but that's a pleasure.'

Diana is, at heart, an intensely practical person. It is this aspect of her character that enables her to look objectively at both herself and her position in the field. It is also a quality that informs her creative practice. 'Because I'm a practical person

PAGES 54–55
View over Faro, Algarve, 1990
Gouache painting, 42 x 59 cm.
Photo by Simon Olley

embroidery
The Journal of the Embroiderers' Guild

Volume 17 no 3 Autumn 1966 Three Shillings

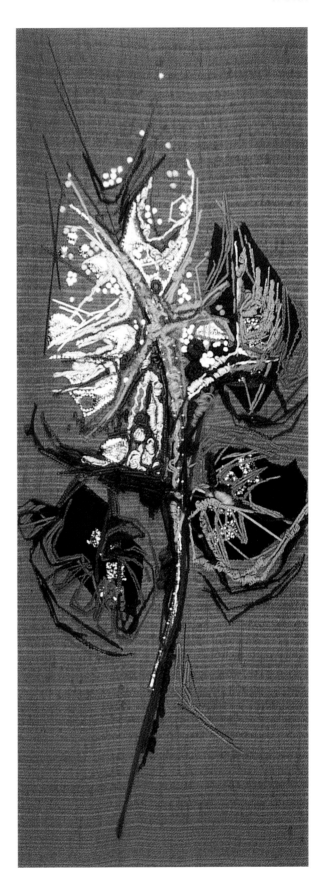

Cover of *Embroidery*, Autumn 1966

Depicts *Blackberry* (right) purchased for the Embroiderers' Guild collection. Gold kid, velvet and rayon applied to a slub silk ground. French knots, couching and straight stitches embroidered in wool, lurex, perlita and cotton perlé, 61 x 22cm.
Photo by Diana Springall

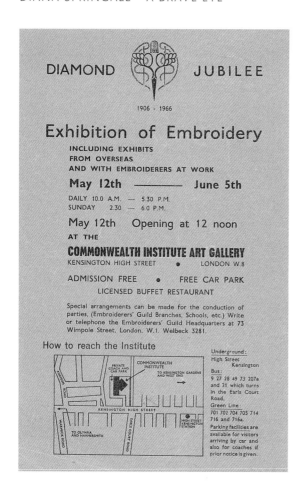

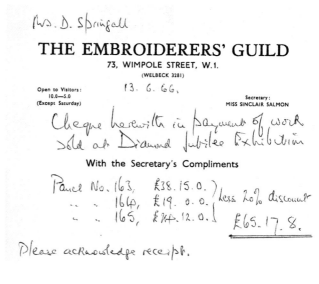

LEFT Poster for the Diamond Jubilee exhibition of the Embroiderers' Guild at the Commonwealth Institute London, 1966

ABOVE Receipt for the three works sold at the Diamond Jubilee exhibition

driven by the client, I don't have the enormous amount of speculative work that you'll see from other artists. Commissioning is about pleasing people, being with people – you build friendships. Speculative is a dialogue with yourself – an inner thing. My depth as an artist is butterfly level. I'm just a practical mumsy sort – sooner go make something useful. I like meeting people's needs – I'll make anything I can.'

That is not to say that Diana has not made any speculative pieces – far from it. In the years immediately after art school, even whilst grappling with the commitments of her very young family and a full-time teaching post, Diana produced a series of creative embroideries. Hand-stitched in wool on fine canvas, these early pieces explored two of her favourite subjects: gardens and landscape. *Blackberry*, *Three Flowers* and *Birds in a Tree* were included in the 1966 Embroiderers' Guild Diamond Jubilee exhibition at the Commonwealth Institute. All were well received and each sold: one to the Embroiderers' Guild, one to ILEA[iii] and one to a private collector. *Blackberry* was selected as the cover image for the Autumn edition of *Embroidery*, whilst *Three Flowers* was described in the exhibition review as 'using traditional techniques in a decorative way' and possessing 'stitch interest and subtle colouring'.

Three Flowers, 1966

Canvas embroidery – stitches include tent, rococo, gobelin tied, gobelin encroaching, Turkey knot, eyelets and satin stitch diagonal. Each motif applied to the hessian ground, 30 x 20cm

Illustrated p.84 of *Embroidery* Autumn 1966. Collection of David Prior. Photo by Diana Springall

These were important pieces, demonstrating both Diana's technical accomplishment and her use of embroidery as a form of creative expression. This combining of craft skills and artistic sensibilities – instilled during her time at Goldsmiths' – was further explored in her book *Canvas Embroidery* which was published three years later. The text on the slipcover made clear her approach to the subject:

> 'Diana Springall believes that necessary though technique is, the most rewarding element in embroidery lies in a conception which is individual and, so unique. Not only should the design be a personal one, but the stitches should be used in an appropriate and characteristic way.'[iv]

The need to thoughtfully combine technique and concept in order to create an integrated whole, is something she has maintained throughout her career. She explains her position further in the book's introduction:

> 'A great deal has been said superbly by Constance Howard in her book, *Inspiration for Embroidery*, on the subject of inspiration for ideas in general. It is therefore not my intention to cover "where to look", and "how to look", in the same way, for this would be pointless. The purpose is to emphasise and assist in aspects of "what to do when one has looked", but with canvas embroidery in mind, for a design cannot succeed unless it is entirely suited to the medium into which it is to be translated...
>
> The main emphasis is, however, on the enormous value of original thought, however simple the initial ideas, and to stress and prove that originality can be achieved right from the beginning. It is hoped that this book will prove that there is limited pleasure in pure technique and that the real pleasure and satisfaction lie in an individual and unique conception and that this, also, has a great deal more to offer to those who look at it. Not only should the design be "yours", but the stitches should be used in an individual way. It is not a question of whether all the stitches are known to the embroiderer that counts, but whether one or two can be satisfactorily selected to fulfil perfectly a specific purpose in the particular project being undertaken.'

Although Diana has always spoken of the merits of embroidering pre-printed designs, here she is arguing for the value of something else: of stitch as a medium for personal creative expression. There is no contradiction for Diana in this. She sees a place for both. She also appreciates that the knowledge of one may lead to the practice of the other. That is her story, and much of her career has been devoted to opening up that same experience for others. 'I feel anyone can learn the technique from books. I show how to get ideas and transpose them so you really get the technique of designing.'[v] 'People want to know what they can do themselves, not what I can do.'[vi]

Birds in a Tree, 1966
Purchased by the Inner London
Education Authority. Photo by
Diana Springall

Wrotham Landscape (1967) is another significant embroidery produced by Diana during this period. Inspired by the landscape near her home, the piece illustrates Diana's repeated use of that which is around her as a potential design source. Made for her parents, this particular piece has added meaning. It represents their acknowledgement of, and support for, her creative practice – something that had been denied throughout her years at art college. Diana's parents bought *Wrotham Landscape* from her. She used the money to purchase her first sewing machine – a Bernina 210 which is still in daily service.

Diana's opportunities to work creatively with her new machine remained limited, however. Other commitments continued to occupy her time, including several lecture tours to North America. Then came two turning points, each difficult and potentially devastating. In 1975, Diana's marriage was dissolved. Five years later she was made redundant; Stockwell becoming one of several colleges to be closed in response to a reduced demand for teachers as the baby-boomer school years came to an end.[vii]

Diana was now a single mother looking to establish a living that would support her family. Once again, the character acquired during her formative years stood her in good stead: 'I am able to accept when something's not working and walk away without bitterness. It's tough but life's tough. If you want to do something, you will. It's a question of sticking at it.'

[i] *Embroidery*, Summer 1984, Elizabeth Benn

[ii] http://www.vam.ac.uk/collections/textiles/features/embroidery/Embroiderers/diana_springer/index.html

[iii] Inner London Education Authority 1965-1990 This work was subsequently lost. One other work of Diana's acquired by the ILEA was given to the V&A when the organisation was disbanded

[iv] *Canvas Embroidery* 1969, BT Batsford, Diana Springall text on slipcover

[v] *Richmond News Leader* April 23, 1982

[vi] *Home and Freezer Digest*, June 1988, Carol Bullen

[vii] *Hansard*, 29 March 1977 vol 929 cc367-78 Report of debate on potential closure

Wrotham Landscape 1967

Machine appliqué with hand stitched free lines; jet beads secured with detached buttonhole stitch, 80cm x 100cm. Owned by the artist's parents Gordon & Stella Alexander. Photo by Simon Olley

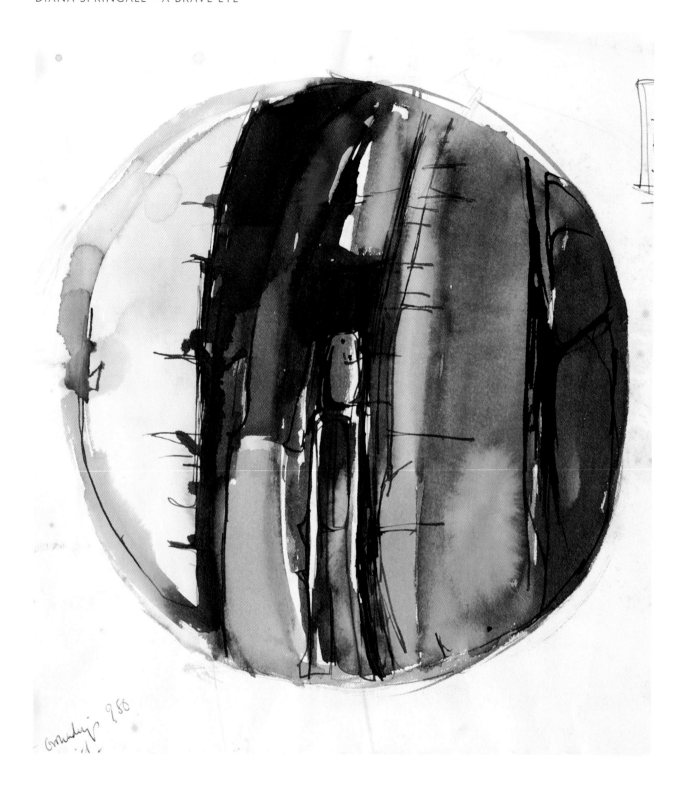

Sketch for *Bark*, 1968. Photo by Simon Olley

'The design was not related to the true colour of the subject, but was selected by placing together wools that were already in stock, and then designing on paper with these and the initial studies in view. Quantities and positions of colour gradually found their place after arrangement and re-arrangement.'

Bark, 1968

Florentine stitch in wool thread. Motif for cover of *Canvas Embroidery* which
was published by Batsford in 1969. Collection of Mrs R Fowler

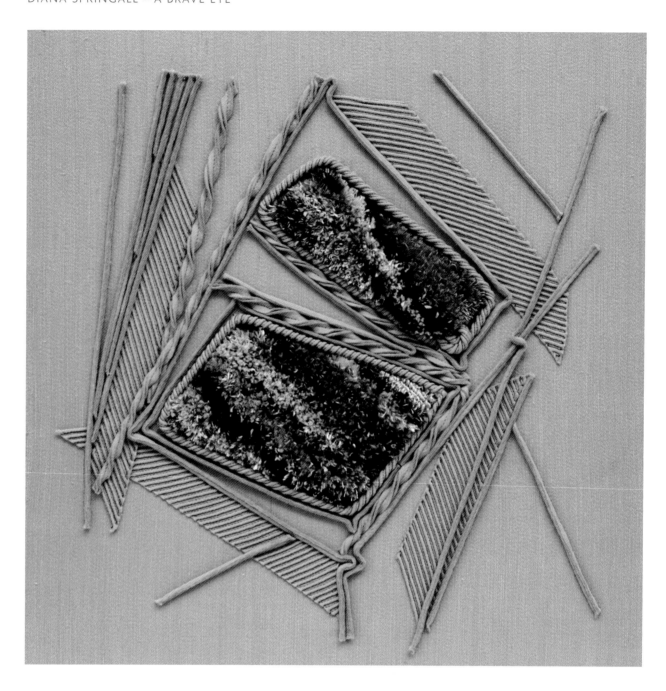

Violas for Chelsea (pink), 2000. Photo by Simon Olley

Low relief panels with hand-tufted loop pile stitchery in silk and felt piping
applied to a dupion ground, 57 cm square

Part of a series of speculative works based on the national collection of violas
held at the time by Richard Cawthorne in Swanley, Kent

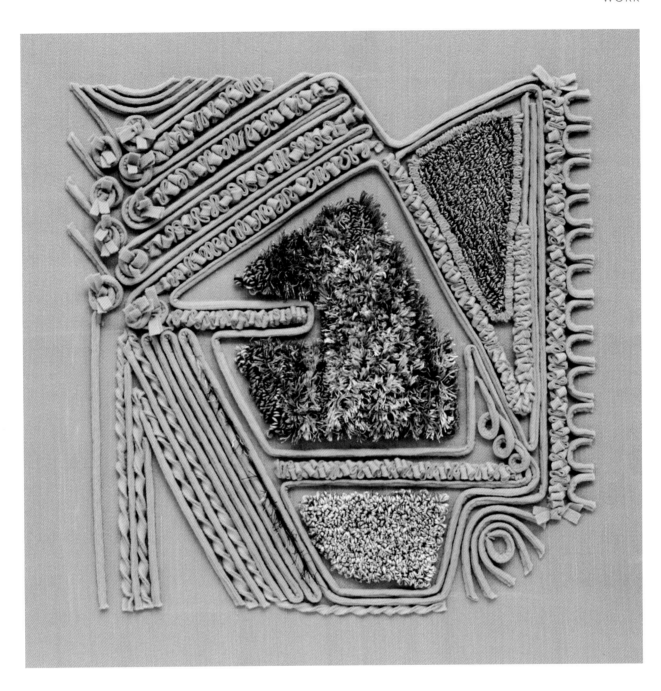

Violas for Chelsea (green), 2000.
Photo by Simon Olley

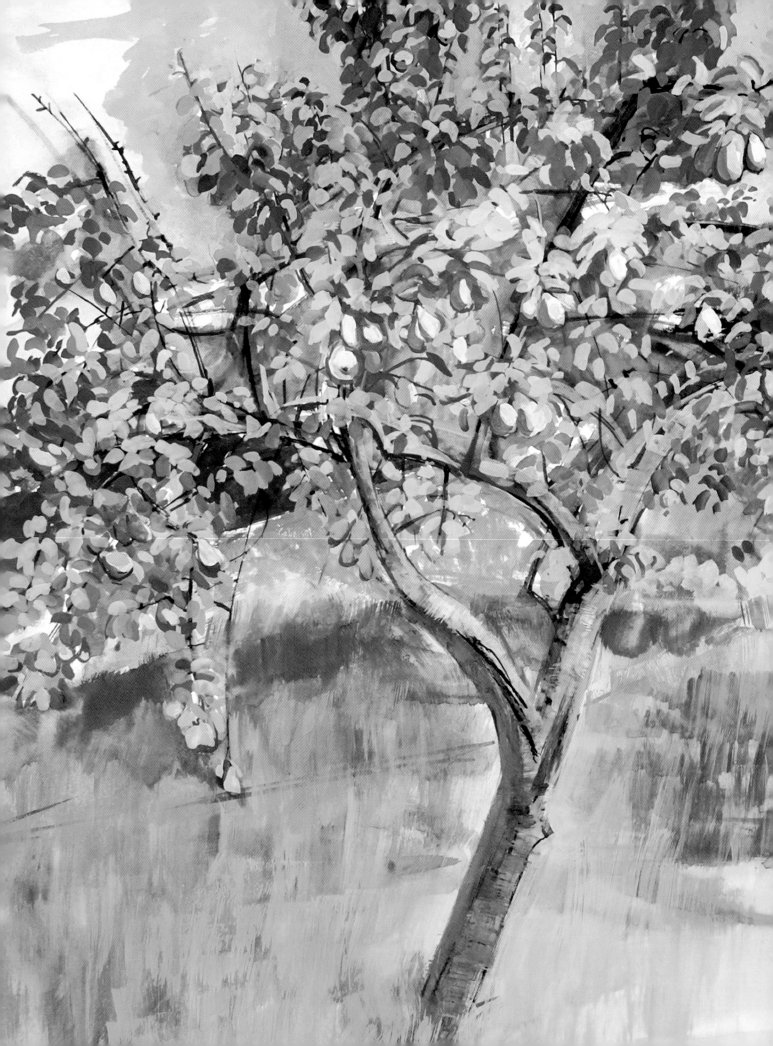

5

Oast Cottage

'I knew when I saw the place it was going to provide enough privacy and peace for creativity and yet not be unwelcoming to those living around me.'[i]

Diana and her two sons moved into Oast Cottage in 1975, shortly after her divorce. Richard was 10 years old, Lawrence 6 and the house a partial ruin.

Located in Kemsing, a typically English village in the Kent commuter belt, Oast Cottage dates back to the seventeenth century. Its name reflects its history, part of the building having been used to dry the hops which were such an important local crop. By the time Diana acquired the house, however, it had been severely neglected and was largely derelict. 'I lived under tarpaulins whilst my sons...slept in the only dry part of the cottage.'[ii] It would be eight years before the building was made fully waterproof.

Drawing on her aptitude for scaling-up, Diana set about restoring the cottage to something like its original state. It was a major project and Diana was to be her own architect. A lengthy and costly undertaking, the house was made habitable by stages. 'If it worked and it was okay, it stayed. I couldn't waste time and money on it. Just waterproofed it and tiled the floor.' Gradually, however, Oast Cottage was transformed into the place Diana had envisioned on that first visit – a comfortable home with adequate workspace and a well planted garden that was to be 'a constant inspiration'.

The impact on Diana and her sons was entirely positive. The refurbishment of the building gave Diana valuable, first-hand experience of working creatively in response to a physical space. It was something she excelled at, and something she was able to channel into her professional career. In an interview in 1988, she explained: 'I'm very interested in interior design and like making things for specific sites to suit an individual client and environment. I've always enjoyed making things for buildings and now feel this is where the main part of my work will lie.'[iii]

Equally important for the family, was the making of Oast Cottage into a warm and caring home; a place for them to enjoy and one to be shared with others. 'It's open house here – if people need help, they just come. They don't need an appointment.'

Malachite III, 1972
Low relief panel in wool felt and velvet, hand and machine stitch, 27 x 33 cm. Photo by John Hunnex

Mandy Carr, a friend of Lawrence's and now vicar of a nearby Parish, recalls her own teenage years with the family at Oast Cottage. 'I didn't have the easiest adolescent time but Diana was always friendly and kind. The garden was gorgeous in summer and I just loved those days – sharing a traditional tea. Diana would say – "are we going to have tea together?" It always made me feel special. When I turned up, she always made me feel I was doing her a favour. It was just part of the things that went on there.'[iv]

As more of Oast Cottage was made habitable and Stockwell's future grew increasingly uncertain, Diana's home became the base for her working life. The conversion of the old hop kiln into a guest wing proved especially significant. Always welcoming of others, Diana was now able to offer residential courses for students. Absorbed into the family for the duration of their stay, each student received individual tuition. Meals were shared together and all could accompany Diana on any professional commitments she might have scheduled. 'I find out what they want to work on, and start their project immediately after they get here. Whatever running about I have to do, they feel free to come with me everywhere.'[v] These sessions were much valued by the students and a number returned year on year. Most stayed for a week, some for a fortnight and one for a month and a half.

Alongside her teaching and lecturing commitments, Diana also continued to develop her creative practice. *Landscape 1* (1976) being one of several pieces produced during this period which mark an important shift in her making. 'This was way back in 1970s and I'm combining line with colour. I would have seen nothing like these.' This was a doubly significant development: there was the bringing together of two elements which fascinated Diana – line and colour – and there was the introduction of sculptural form, the lifting of the line from the surface. 'I've always been interested in line and the semi-sculptural. I just somehow loved line and wanted them lifted. The more I drew, the more it seemed right to lift the line. And I love self-colour.'

The emergence of these concerns in her work can be traced over several years. *Lenham Landscape V* (1974) and *Ash* (1974) both used multi-coloured hand-patchwork to create a flat surface which was overlaid with low relief piping. This was line applied to colour: a delineation of mark on a variegated surface. At the same time, Diana was also beginning to produce monochromatic works; sculptural forms where the linear marks created colour. *Malachite* (1972) and *Wood Grain* (1974) are early examples of this approach; *Book of Kells* (1981) a more complex and ambitious development. All involve a process of paring down – of colour and materials – and focus on tonal qualities achieved through the effects of light on texture and raised surfaces.

Although Diana would continue to create vibrant, polychromatic works throughout her career, the use of self-colour was to become an increasingly important part of her practise. 'I'm always painting and drawing and as I do so, large panes of colour or maybe a sculptured treatment suggest themselves to me. But whilst I enjoy working with bold colours, I also find just as great an impact is made by leaving them out of a piece.'[vi]

As important as Diana's art training was to the conception of these ideas, her technical skills were integral to their execution. 'I work from a palette of fabrics to help decide what to use where. I use them in the same way as I use paint. By placing the same piece of fabric at different angles I can get maybe four different colour effects from it.'[vii] Diana was playing with the lie of the nap to create subtle shifts in tone. This might involve working with one material or the juxtaposition of different textures: felt and velvet; silk and cotton. Whichever method was involved, it was the nature of the cloth that was being used to create gradations of colour.

The low relief lines that fascinated Diana were equally complex to achieve as a textile form. Each had to be made individually, using a process she herself devised. 'I...discovered this way of lifting a surface without using colour. The piping is simply felt strips folded over piping cords which are sewn very closely with a zip foot, then hand sewn on to the background, so that I can make all the final movements as I sew – though of course I always draw first and then scale up the drawings. I use piping both raw edge up and down – sometimes trimmed, sometimes gathered – and so on.'

It was a relatively uncomplicated but physically demanding technique. The result – the creation of raised linear and curved lines – was one Diana had been working towards for some time.

RIGHT *Malachite IV* 1972

Low relief panel of wool felt on dark blue velvet ground, hand and machine stitch, 90 x 140cm. Photo by John Hunnex

'The Malachite series started with a "hankering after an immense amount of colour" and an impulse towards silks and velvets in luscious bottle greens and turquoises but was paired down to midnight blue felt piping on velvet – a colour rewardingly vindicated when she learned later that the chemical composition of malachite is basically cobalt.' (Elizabeth Benn, *Twelve British Embroiderers*, p 108)

RIGHT *Malachite I, 1972*
Low relief panel in wool felt, hand and machine stitch, 15 x 17cm. Photo by John Hunnex

OVERLEAF Observational drawings from a malachite stone, 1972

Pencil, crayon, gouache, pen and ink. Photos by Simon Olley

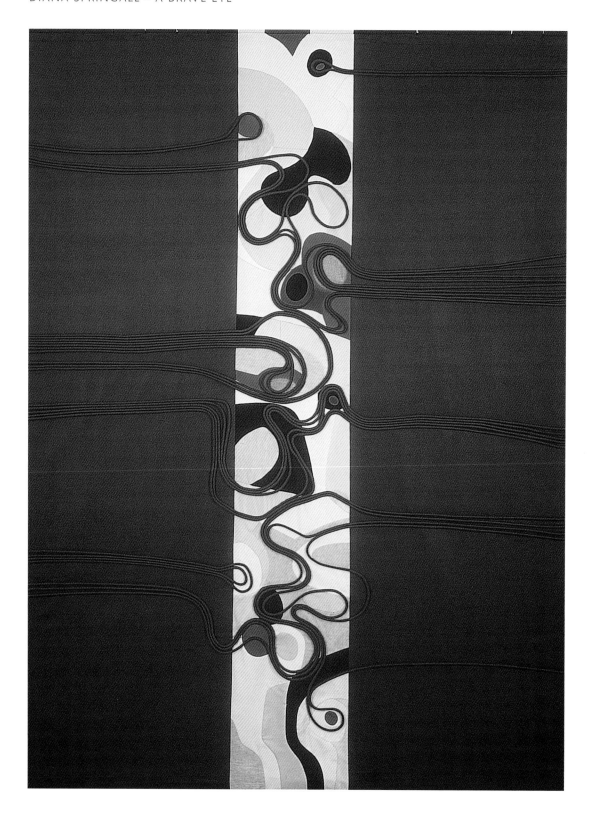

Ash I, 1974
Hanging of hand patchwork set into a wool felt ground with felt piping.
Based on drawings of wood grain, 2.75 x 2.15m. Photo by John Hunnex

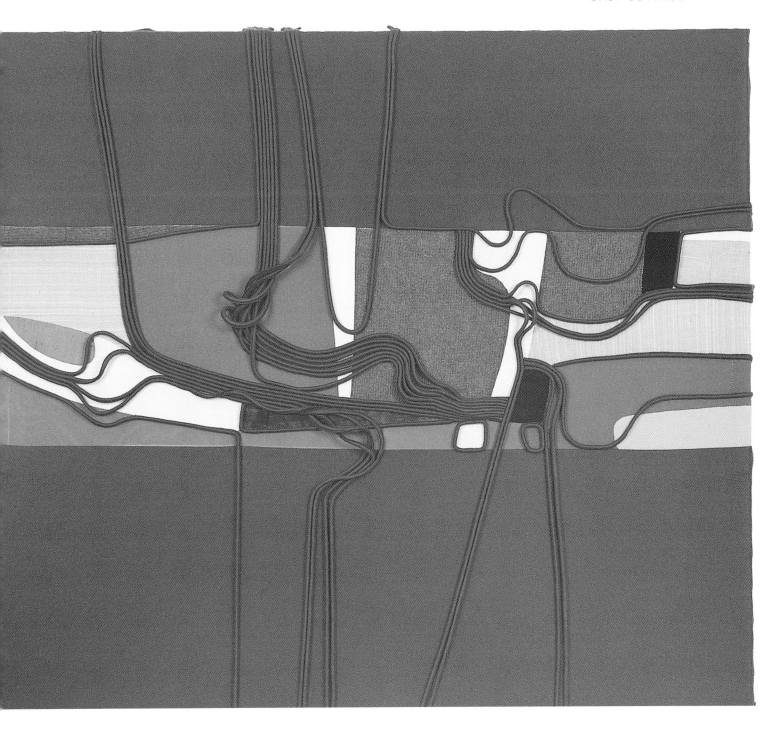

Lenham Landscape V, 1974.
Panel of hand patchwork set into a wool felt ground with felt piping,
61 x 92cm. Photo by John Hunnex

As Diana experimented with colour, line and semi-sculptural forms, she began to create a series of works that were distinctly hers. Whilst the skill and knowledge that underlay this making had been acquired over years of training and practice, the catalyst that brought it to fruition was both unexpected and entirely personal. It was David Piésold.[viii]

'We met at Borough Green station – started chatting, as you do. Then he was travelling first class and that ended the conversation.' An incoming train might have terminated their conversation but it also marked the beginning of their association. From that innocuous meeting, there developed at first a friendship, and then a devoted partnership.

Mandy Carr describes their relationship: 'I've only ever known David being there; I haven't known Diana without David. There was a quiet harmony about them as a couple – a stability and contentment – and also a privacy and gentleness. Both had such a strong sense of honour and decency. Behaving in a way you would want people to behave to you was central to them both, even if that meant someone took advantage. There was a security about their relationship and that security gave her confidence. It gave her freedom to fly.'

The confidence that came from that security had a marked impact on Diana's practice. So much so that, by 1982, she spoke of feeling that her work was just beginning. [ix]

'David batted for me. Just to have someone to tell you "you need a better space to work in than this" – and every day to tell you "you're wonderful". Then you can do things.'

RIGHT *Wood Grain*, pencil drawing. Photo by John Hunnex

BELOW *Wood Grain*, 1974
Low relief panel of white satin and felt on a velvet ground, 61 x 184cm
Private collection of the late Margaret Sandford, Kent Education Inspector, subsequently presented to the Embroiderers' Guild collection.
Photo by John Hunnex

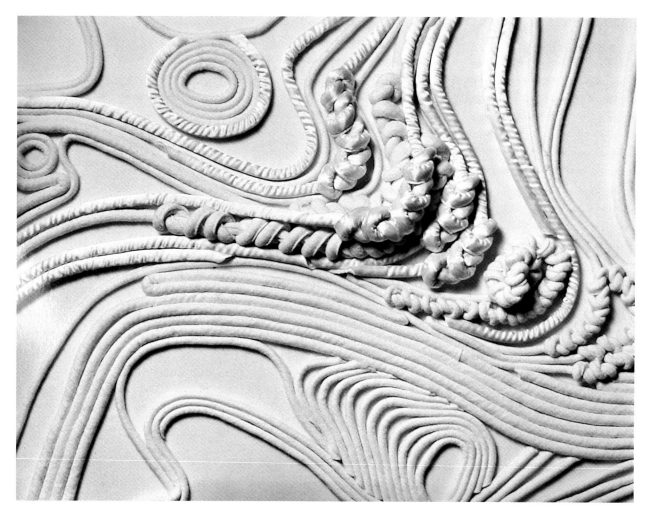

Wood Grain, detail. Photo by
John Hunnex

i *The Well, Kemsing Village Magazine* Autumn 2007
ii *Home and Freezer Digest*, June 1988, Carol Bullen
iii Ibid
iv Interview with the author, March 3rd 2010
v *Richmond News Leader*, April 23 1982
vi *Home and Freezer Digest*, June 1988, Carol Bullen
vii *Home and Freezer Digest*, June 1988, Carol Bullen
viii David Piésold CBE 1923-2008, Consulting engineer and inventor
ix *Twelve British Embroiderers*, 1984 p108, Elizabeth Benn

RIGHT *Book of Kells,* 1981
Detail. Photo by John Hunnex

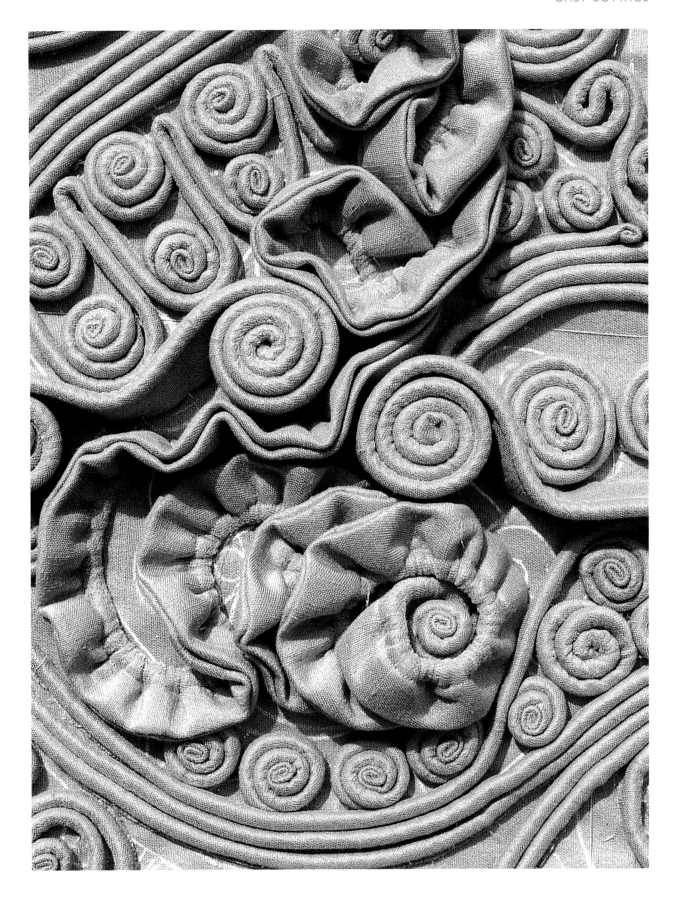

Book of Kells, 1981

Low relief panel with piped cords in gold dupion mounted on the same fabric ground, 61 x 184 cm. Collection of Mrs Cora Coen.

'Kells started with the inspiration of intricate, glorious colours but her design conception became a pale gold relief sculpture of fish, snakes and birds with the name of the commissioning family standing in slightly higher relief (Elizabeth Benn, *Twelve British Embroiderers*, p 107

Detail right

Photos by John Hunnex

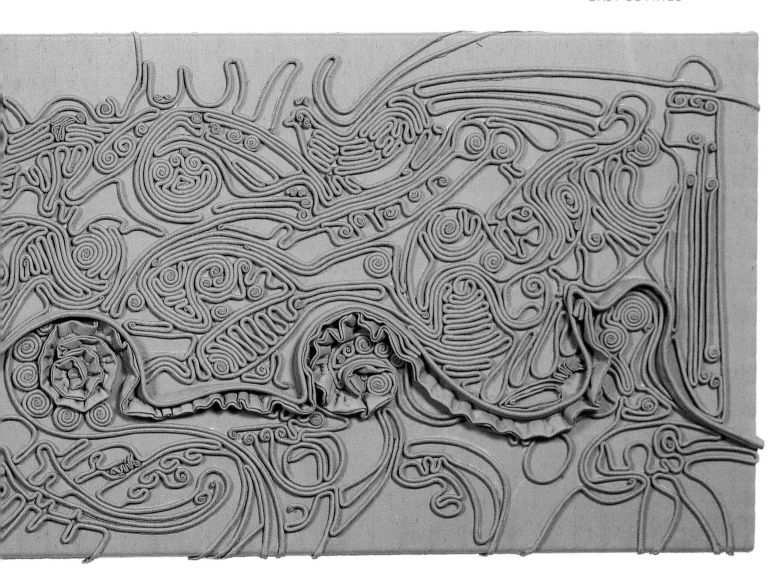

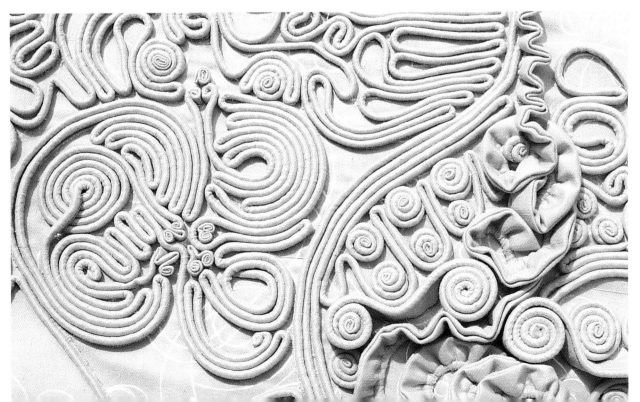

Door Hanging, Oast Cottage, 1984

'The first stage, almost completed, is a hanging which will cover the doorway, parting in the centre in Indian Toran style. The inspiration for this appliquéd work came as she sat under a well-laden apple tree in a Kentish orchard. Her original paintings she felt were too cold and too green to live with comfortably. The final colours are warm greens and pinks, turquoise and olive shades and deep wine reds. [The] shape of the hanging is exactly determined by a door enclosed within a flight of steps.' (Elizabeth Benn, *Twelve British Embroiderers*, p108) 2.82 x 2.66m. Photo by Dave Hankey

Bathroom carpet, Oast Cottage, 1990
Hand tufted in ICI Tactesse
2.34 x 2.10m. Photo by Dave Hankey

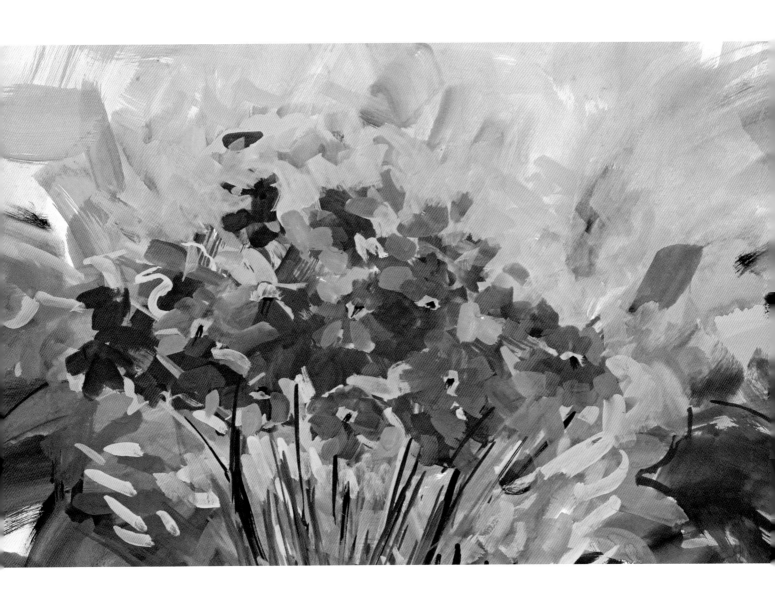

Summer Flowers, 1985
Gouache painting, 20 x 40cm. Photo by Simon Olley
'[Paintings are] my bank of colours: flowers, landscapes – when I
found aubergines went together, I used them for the carpet upstairs.'

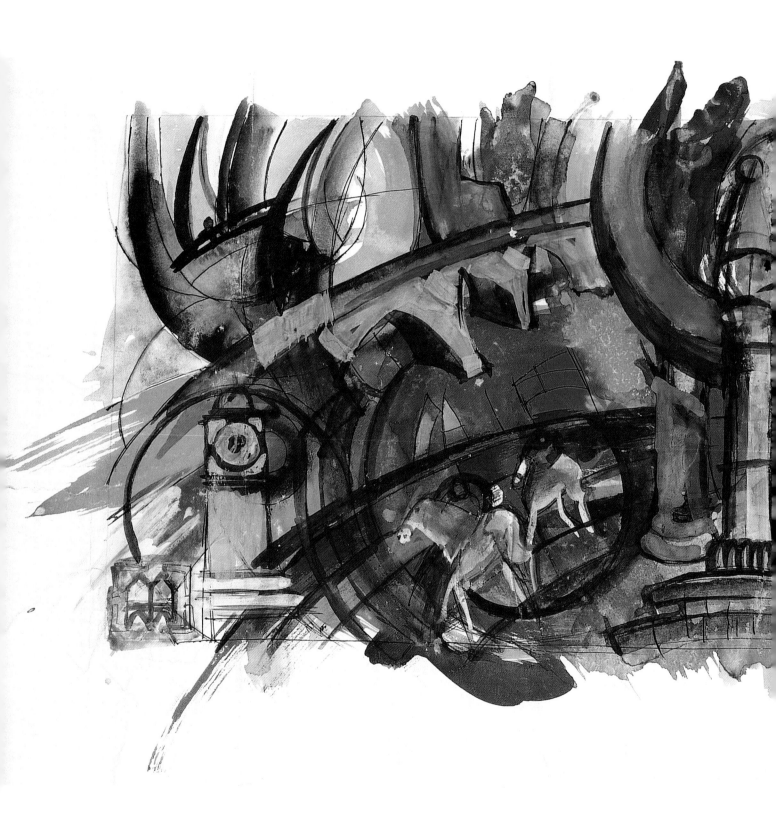

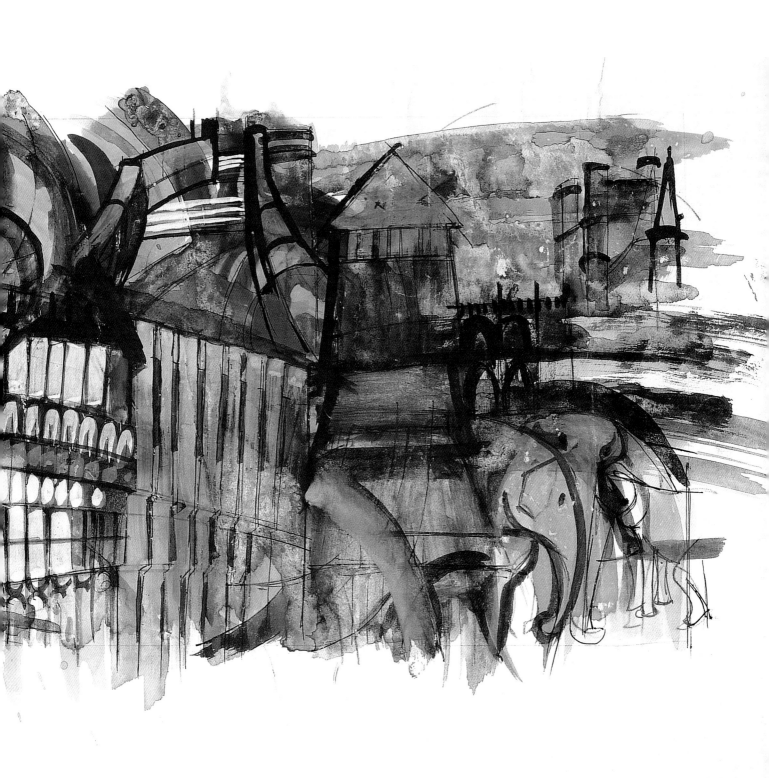

6

Communities

'I'm fascinated by people. I love community projects.'

D iana's move to Oast Cottage in 1975 marked a new phase of her professional as well as her personal life. Whilst she would continue to work at Stockwell for a further five years, the status of the College grew increasingly uncertain as the government reduced teacher training places across the country. Soon Stockwell would be the past; and if Stockwell was the past, then Oast Cottage would be the future.

There were two probable career options available to Diana. She could seek out another position in education, or she could develop her practice as her profession. A testimonial written by Margaret Sandford, a Kent-based education inspector, laid out the qualities Diana would bring to the former.

> 'Mrs Springall ...has high professional standards, approaching her work through a total concept of art education. [Her] principles, integrity, hard work and commitment are such that she would make a major contribution to any senior post to which she was appointed.'[i]

That senior post was not the route Diana was to choose, however. The qualities Margaret Sandford listed would remain the same, but the context in which they were exercised would change significantly. From here on, Diana would focus on establishing herself as a freelance maker and teacher.

The transition from one state to the other was gradual. It had to be, because Diana was building for the long term and lasting plans need firm foundations. Besides, she still had a substantial work commitment at Stockwell and a position that required both time and attention. Perhaps more significantly for her at this stage, that post also provided five further years of financial security – five years breathing space during which she was able to prepare the groundwork for a different future. A small pension released when she was finally made redundant gave some surety, but there was still work to be done as well as the family and home to support. Other plans had to be put in place in order to ensure their wellbeing for the long term.

PAGES 86–87 AND ABOVE
Two gouache sketches – preliminary thoughts for Chester Town Hall project
Photos by Dave Hankey
'The first few colours were not difficult to find because the city is predominantly black and white. Pink also seemed to register clearly the more one walked about the sandstone buildings. It struck me that when standing under the Eastgate clock looking through the wrought iron down into the street I noticed red traffic lights, red buses and the odd scarlet signboard. I realised that a design without scarlet was simply not going to work with any strength. This kind of subject was not one that I could easily transpose – images one upon the other would require drawing and painting simply and quickly done in order to see how one might superimpose wrought iron upon a cathedral or reduce the space between the bell tower.

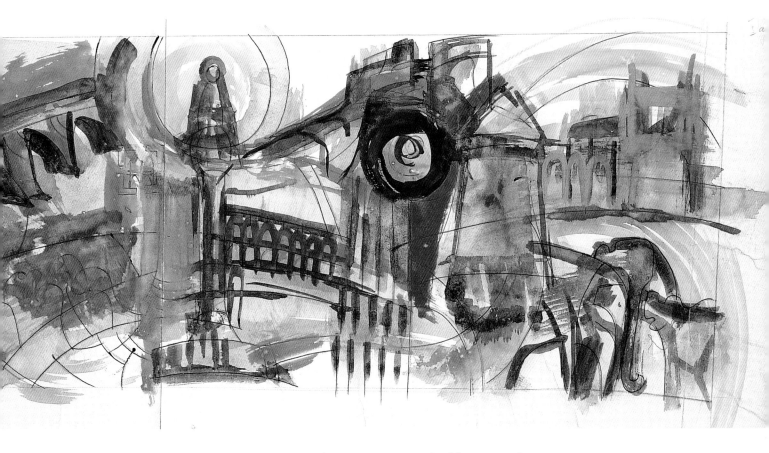

It must have been a difficult time and certainly an exacting one: building towards a new career whilst simultaneously renovating the cottage and caring for two young sons. Yet Diana appears to have been undaunted. It could have been that tough upbringing coming to the fore again. Her capacity for sheer hard work – one of her defining characteristics – certainly did.

Diana seems to have little issue with taking on concurrent commitments and fulfilling each to her own exacting standards. If there was any personal cost to be incurred in completing these projects, then it would be hers alone.

> 'There were many times [Diana said] when she had worked until she got the shakes. Once she had worn her knuckles down, stretching canvas until they were raw and bleeding, and she had to carry on with each finger separately bound up.'[ii]

This ability to retain a high level of sustained commitment combined profitably with Diana's propensity to scale-up projects and her willingness to take on a diverse portfolio. As a consequence she soon became involved in a series of ambitious creative initiatives, each of which helped to enhance her practise and her profile.

Once again, the timing was critical. Having entered Goldsmiths' shortly after embroidery had become accepted as an art form, her emergence as a maker coincided with a period of burgeoning craft practise.

Painting is a necessary stage not so much to make a glamorous end product but one that would give me the greater freedom to manoeuvre one shape against another.' (Embroidery, BBC 1980)

In 1976, the V&A held a week-long exhibition of contemporary crafts. It was an important breakthrough event which showcased the practise of seven makers in one of the Museum's galleries. Diana was one of those invited to participate, as were Walter Keeler, Ann Brunskill, John Lawrence, Anne Hechle, Edward Lucie-Smith and Adrian Pasotti.[iii] The public response to the event was overwhelming. Over 60,000 visitors passed through the exhibition during the seven days it was held and so great was the volume of people that, at one stage, the Museum doors had to be closed as staff feared a staircase would give way under the weight of numbers. Frightening though that was, it did not prevent the event being repeated the following year when seven additional practitioners were invited to take part in what became *The Makers*. Although it did not continue beyond that year, the event had made its mark. It had also given Diana's work a national profile.

Diana's willingness to engage with people wherever they are is a particular strength. She is not afraid to take her work to unexpected audiences. Rather she sees this as an opportunity to involve those who might not otherwise be exposed to creative practise. Her community projects are integral to this: drawing together her teaching ability –that desire to enable others to make for themselves – and her commitment to public art.

Underlying both these aspects of her work is another that is fundamental to Diana: her concern not just for people, but for communities; for people living in relationship to other people. This has been a career long fascination and has resulted in her involvement in numerous community-centred commissions. 'I more or less had group projects end on until just a few years ago,' she explains. And these are very much group projects: the focus being as much on the communal experience as on the final product. Andrew Salmon, Director of Creative Exhibitions, describes his experience of their impact:

> 'Diana ...was the very first artist we chose to feature at the Knitting and Stitching Shows as they migrated from being pure commercial shows and instead became the inspirational events they are today. However, it was a couple of years after exhibiting Diana's work ...that we became truly aware of the quiet influence she has. This was when we resolved to exhibit several community projects and were pleased to show one for which Diana had been the figurehead. It was clear talking to those that had been involved in what was a major activity that had brought church and village together, just how influential Diana had been.'[iv]

Diana's first experience of a community project occurred during that pivotal year of 1975, when she was commissioned to produce five panels for Chester Town Hall. Part of the celebrations for European Architectural Heritage Year, this was a hugely ambitious project that would take five years to complete. Although it began as a commission rather than a community project, it ended as both.

The initial brief had been for Diana to create a group of artworks for the staircase area of the Town Hall, a substantial Victorian Gothic stone building.

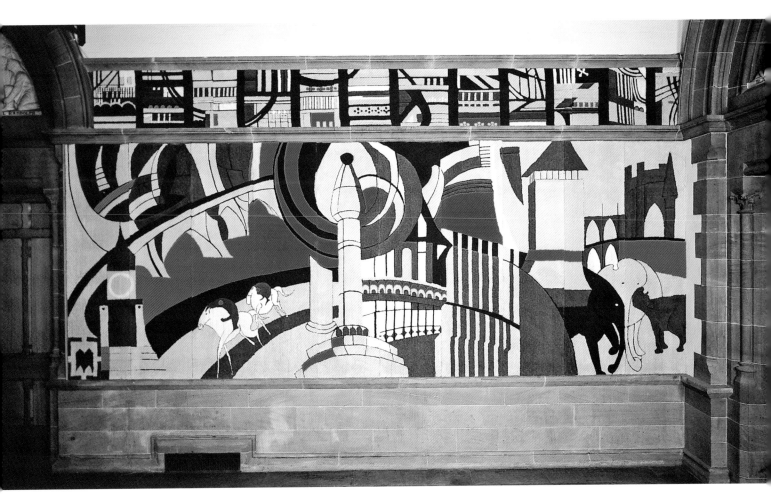

Chester Today, 1975-80

ABOVE Main panel of set of five made for Chester Town Hall. Tent and velvet stitches in Wilton wool on a canvas ground. Worked by 300 local embroiderers.

RIGHT *River Dee Panel, Chester Today,* in situ

'*I was aiming initially for a low sculptural relief – panels that would have to be viewed from the side on first entry to the hall. I chose canvas work because it is the most long lasting of all embroidery techniques – the thread being absolutely integral with the base fabric. It is also one which makes individual work indistinguishable from that of another.*' (*Embroidery*, BBC 1980)

Photos by Dave Hankey

There were five designated spaces for the work: a main panel 600cm long by 60cm high, plus four smaller panels each 240cm long by 60cm high. The work had to integrate into the internal architecture and should focus on the subject of Chester's history.

It was a firm outline. Diana's response reveals much about her approach to site-specific projects. First, there was the subject matter to address, all the while considering it in relation to the particular environment. Concentrating purely on the history of Chester she reflected, 'seemed a little over rich and one that could possibly end up as a representational and detailed story instead of an interior design with impact in its architectural setting.' Having identified a problem, she then proposed a solution that would be sympathetic to the original brief. The work should incorporate contemporary as well as historic references to the town. It should be about past and present: *Chester Today*, not Chester yesterday.

'The essence of [the] original idea was retained by the inclusion of the Roman walls and crossing but these aspects were placed alongside the contemporary Bell Tower and concrete car parks, zoo and racecourse, thus creating an amalgam of ancient and modern elements existent in Chester today.'[v]

Given the scale of the spaces and the funding available, it was clear that this was beyond the capacity of one person to make and Diana developed the idea of her creating a design which could be worked by local groups. The material and techniques she selected would be vital. 'Where a vast number of workers are involved with a particular project, a stitch which maintains the unity of the whole piece is important.' Taking everything into consideration, Diana decided the piece should be worked in wool, using a hand-knotted carpet technique.

Having agreed the design and process with her client, Diana then implemented the project: scaling up the design, transposing it onto canvas, demonstrating the technique at twenty-eight group workshops and making reference samples. It was an immensely ambitious and time-consuming project that took five years to complete. Question Diana about the making of the panels, however, and she will insist on changing the focus from herself to the contribution of others. 'Katie Thompson and Dorothy Colley were the driving force of the project. They were both members of the Chester branch of the Embroiderers' Guild and they worked alongside all the groups. They supported, advised and befriended everyone who worked on the panels. They were just amazing – they lived it really.'

The project attracted considerable interest and was covered in the BBC 2 series *Embroidery* on which Diana was also involved. It also more than fulfilled the brief Diana had been given at the outset: creating a genuine community spirit as well as five striking panels. 'When we began, perhaps one person in eight had considerable experience, the rest rather little. I taught them stitches in workshop sessions. And when it was coming to a close, they said: "Can't you think of something else you can make?" The tapestry had been such an experience of camaraderie and friendship.'[vi]

RIGHT *Friesian Cows, Chester Today* detail

'It seemed important to include pastoral scenes featuring the Friesian cows who so nobly provide the Cheshire cheese.' (Officespec, 1988 p106)

OVERLEAF *Racecourse, Chester Today* detail

Photos by Dave Hankey

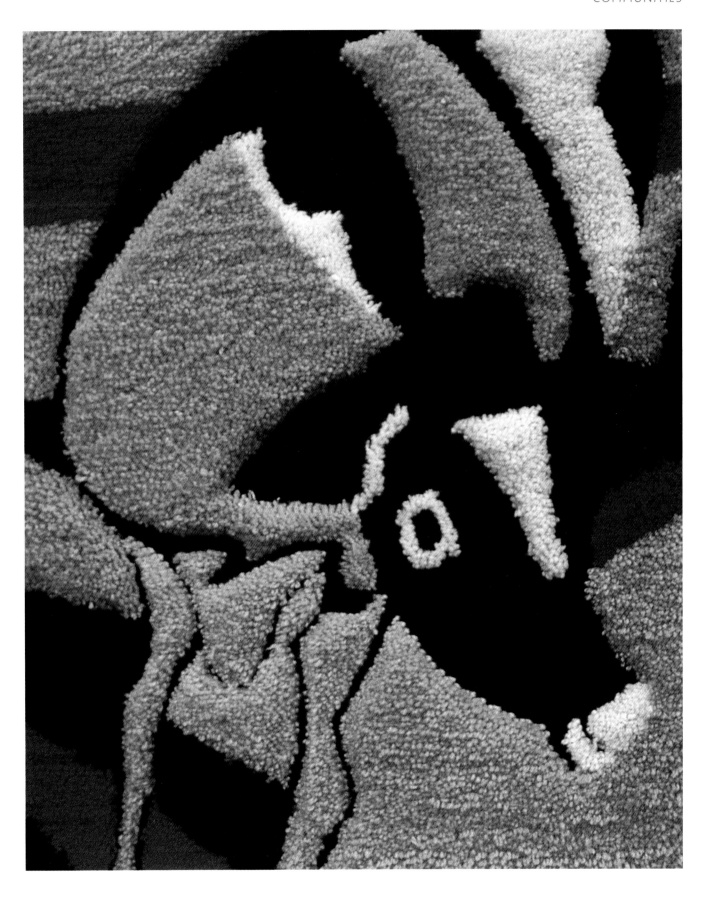

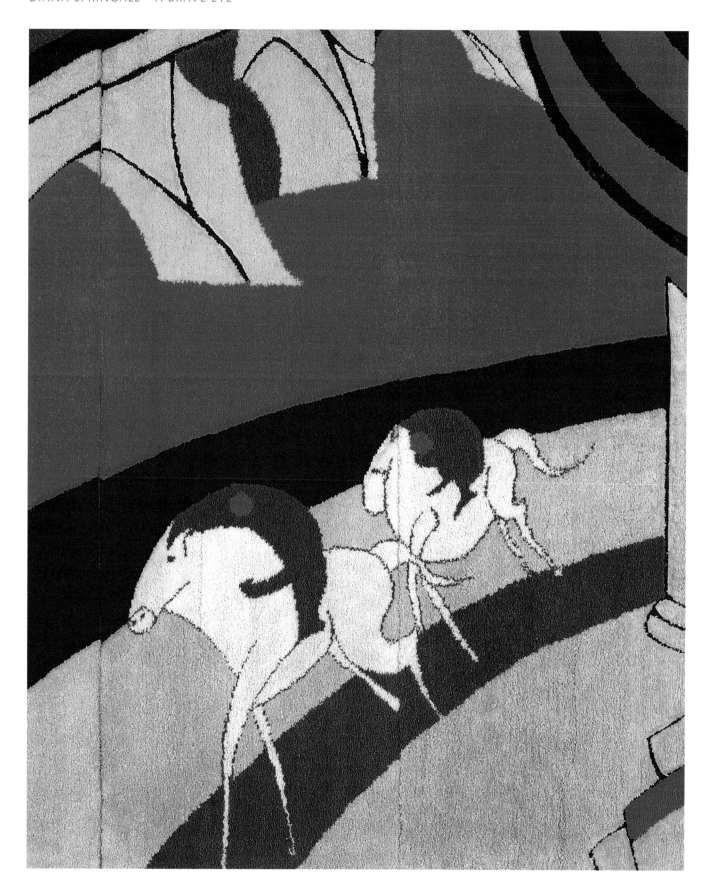

That sense of camaderie and friendship is as important to Diana as the making of a work that satisfies the clients needs. Finding a resolution that fulfils both is something that intrigues her. 'I like solving a puzzle – because that's a commission really.'

In at least one commission, the puzzle became the resolution. 'I responded to a call for expressions of interest for a Millennium project at Dunsfold Church. It was an open competition and I was fortunate to be the one whose design was selected. It was a huge community project and they were wonderful clients. They wanted something for the inside of the church that would represent everything that was important to the village. There were all sorts of things – the cricket club, listed buildings, wildlife, a drama group. Eighty-five things in all, and they were all so different. I thought how can I bring it together and then I had the idea of a jigsaw puzzle. I'd always wanted to do one. So I made this design where each element would be made as a separate block and then the whole bolted together. I kept the design simple so everyone could take part and used two stitches – tent stitch for a flat background and cross stitch for the raised image.'

Ladies from 'Friendship Club' working on the Chester embroidery. Image taken from BBC2 *Embroidery* 1980.

It sounds simple, but that simplicity reflects the sensitivity and depth of thought Diana brings to each project in her desire to create a project that enhances both the place and its people. Her commitment is total and, whilst she delights in involving others in making, she is clear about her own responsibility for the successful completion of each undertaking: 'Joint projects...produce a tremendous amount of goodwill and community spirit. But the artist designer must co-ordinate the work in progress.'[vii] The letter sent to her on the completion of the *Dunsfold* project testifies to its impact on the village:

'Everyone is thrilled with [the tapestry]. It fits the church well and is an exciting piece of design. It is splendid that we envisaged something altogether more modest and achieved this. [You] did so much that you need not have done, the visit to the school, the support of the tapestry when it was exhibited [at the *Knitting and Stitching Show*], the very personal help that you accorded to everyone who needed it, the photographs of the finished piece. You must have burned the midnight oil beyond the requirements of the specification. We have a treasure which we greatly appreciate.'

[i] Testimonial, Margaret Sandford, Inspector for the Education of the Older Girl, March 1975

[ii] *Sunday Telegraph* March 29 1987

[iii] Diana demonstrated embroidery; Walter Keeler ceramics; Ann Brunskill etchings; John Lawrence wood engravings; Anne Hechle calligraphy; Edward Lucie-Smith poetry and Adrian Pasotti box-making. *The Makers*, published by the V&A Museum Press, 1976

[iv] Correspondence with the author, 7th September 2010

[v] *Officespec*, 1988 p106-7, Kate Southworth

[vi] *Sunday Telegraph* March 29, 1987

[vii] Artist lecture notes

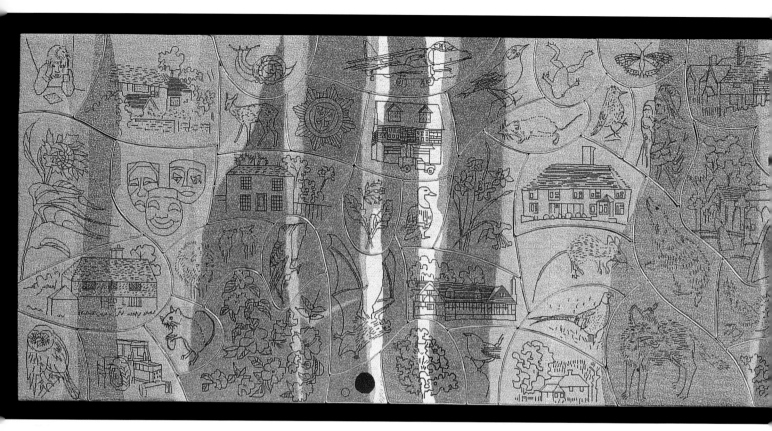

Dunsfold Millennium Embroidery, Dunsfold Church, Surrey, 2000

Tent and cross stitches in DMC perlé cotton and light gold thread on a canvas ground. Worked by the villagers of Dunsfold. 1.2 x 5.30m

'The embroidery hangs beneath the stained glass window on the west wall and is designed to reflect the colours of the window as if they are streaming down into the tapestry in rivulets. It is huge, contemporary and dramatic. In a little piece of theatre, a light switches on as you enter and the tapestry becomes a glistening blaze, since every stitch is counter-crossed with gold thread. Closer still, you can see that it is made out of 85 jigsaw-like panels mounted on a board, each piece edged with yet more gold.' (*Country Life* March 30, 2000)

LEFT Dunsfold embroidery trial sample

RIGHT Dunsfold commission under construction in artist's studio

Photos by Diana Springall

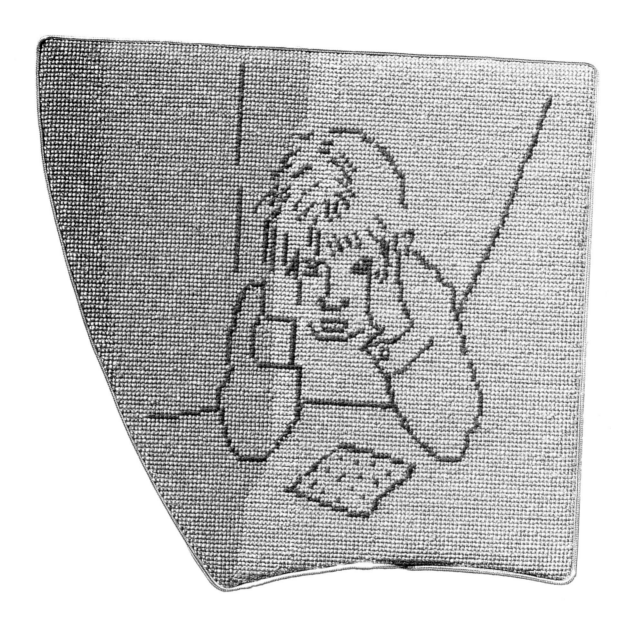

Two of the Dunsfold commission jigsaw pieces:
ABOVE Schoolboy, RIGHT Village house
Photos by Diana Springall

7

Commissions

'I am passionate about the need to encourage corporate patronage...
for art in architecture.'[i]

Diana's first commission was an altar frontal for Farningham Church that she
made in 1973. She was then eleven years out of art college and developing
a plurastic career as a textile advocate. Commissioning was to become an
increasingly important element in her practise; as much a process of working as
an outcome.

Diana describes commissioning as 'building an end product that's a wholeness.'
It is about 'creating something meaningful to the client'. These qualities underlie
every aspect of her work. Each project is conceived as an integrated whole and a
potentially meaningful source of engagement. This is the approach she brings to
her teaching, her committee work, her collecting and her publications. Everything
is done in context and as a dialogue: all is externally focused and all is of purpose.
These are personal strengths and they are seen at their best in her work for site-
specific commissions.

That initial commission at Farningham was one of many ecclesiastical projects
Diana would undertake, alongside a series of projects for offices, synagogues,
private homes and public spaces. Whatever the particular setting, her start-
point was always the same: a consideration of the work in relationship to its
environment. The architecture, internal furnishings and fittings, specific colours
in the carpet or window glass were all taken into consideration. Each design
would then be developed as a sympathetic response to that particular context.

This integrated approach to design had been instilled in Diana during her art
training and it was something she was to develop into a personal aptitude. 'The
background is as much a part of the whole as the original subject matter and must
be considered', she had written in *Canvas Embroidery*.[ii] It was advice for designing
stitch-work on canvas, but it was a tenet she applied equally to other forms of
practise and was especially pertinent to site-specific installations.

Colour, line, imagery, texture and symbolism are all referenced in Diana's
designs, although not always in an overt form. 'I tend to try and make pieces which
challenge the viewers perception and if they were quite able to understand the
significance of the symbolism at a first viewing, I should be rather disappointed.'[iii]

PAGES 100–101
Falcon sketches, 1990
Gouache. Photo by Simon Olley

102

Trinity Altar Frontal, Farningham Church, Kent, 1972

Raised lines of felt piping echoed the ogee shapes around the furniture and within the stained glass above. The relief is contained within three vertical areas leading the eye directly to the candlesticks. 92 x 246cm

RIGHT *Trinity Altar Frontal*, Farningham Church, detail

Photos by Dave Hankey

The intention is to create a work that will reward continued viewing, rather than one that will reveal all in a single gaze. Then, there is the human context to consider and her concern to present a positive focus.

> 'I would be reluctant to produce art which inspired a violent reaction because I personally do not like to feel distressed and I'm sure other people feel the same way. In the office environment there is enough tension and pressure without invading the atmosphere via the artwork. All day there is a certain emphasis on the timetable and the meeting of deadlines and therefore, I believe art in such an environment should produce a calming influence.'[iv]

Diana's commissioned works are immensely varied. No two are alike: each represents an individual response to a specific need. All are identifiably hers, however, and all share the same process of making.

Each design begins with the receipt of a brief: a project specification drawn up by the commissioning body. Some are detailed, others more open. Whatever the remit that is set, Diana's aim is to create a work appropriate to that particular context. Conversations with the client and site visits are integral to this process and are arranged at an early stage. This research phase marks the start of a dialogue – with people and place – that will continue throughout the project. Once an idea has emerged, it is worked up as a design on paper; discussed with the client and amended as required. It is only when the form, imagery, colour and materials have been mutually agreed that work will begin on the physical making of the piece in fabric.

No matter how precise the brief, the journey from concept to actuality is rarely straightforward. This is where Diana's love of a puzzle comes into its own as she worries out the resolution to a quandary or an apparent tension between aesthetics and practicalities.

Invited to design an altar frontal for the chapel at *RAF College Cranwell* to mark the 50th anniversary of the Battle of Britain in 1990, the brief Diana received did not immediately excite her. 'They said it has to be birds and a crown and crosses. It wasn't promising. Then I asked what type of birds? "Falcons." So I made an appointment to see the falcons at Chilham Castle in Kent and I asked if they could be let out. Eddie Hare – the falconer – kindly did so and when the birds flew, their wings were stretched out and they were like aeroplanes.' As she watched the falcons, Diana made a series of quick sketches. Working back in her studio, those drawings became the basis for her design.

Made in appliquéd silk – a reference to stained glass – the completed frontal contains all the elements stipulated in the brief, but the interpretation is lyrical rather than literal. Four falcons dominate the cloth, the crosses concealed in their wings. A single crown sits above and to one side, almost an allusion in monochrome. Fluid lines hint at the movement even rigid aeroplane wings can make. The colours are of earth and sky combined in one glance and then, above, the clouds.

Altar Frontal, RAF College Chapel Cranwell, 1990

'Worked entirely in Thai, Indian and Tussah silks – all producing intense and sometimes "shot" colour – are sewn down with narrow rayon machine stitch, the latter chosen to link with the existing pale gold cross and candlesticks.' (Notes for *British Ecclesiastical Embroidery Today* exhibition, St Paul's Cathedral 1990)

'My overall aim for the design was to continue the silhouette of the sky- as it appears through the clear glass of the chapel windows – through into the top of the frontal- sky in this being in my mind almost more important than anything else. [The] crosses are deliberately discrete... thereby introducing an element for deeper perception. A single crown – ornamental yet technically restrained – is placed carefully to symbolise Queen of both Heaven and Country – a few similar detached rings float beneath to become eyes of the birds. In offering these shapes and movements it was possible and appropriate to work with a very rich group of colours thereby giving the chapel a "stained glass" in fabrics which, because of its serene simplicity, it could support.'

92 x 246cm. Photo by Dave Hankey

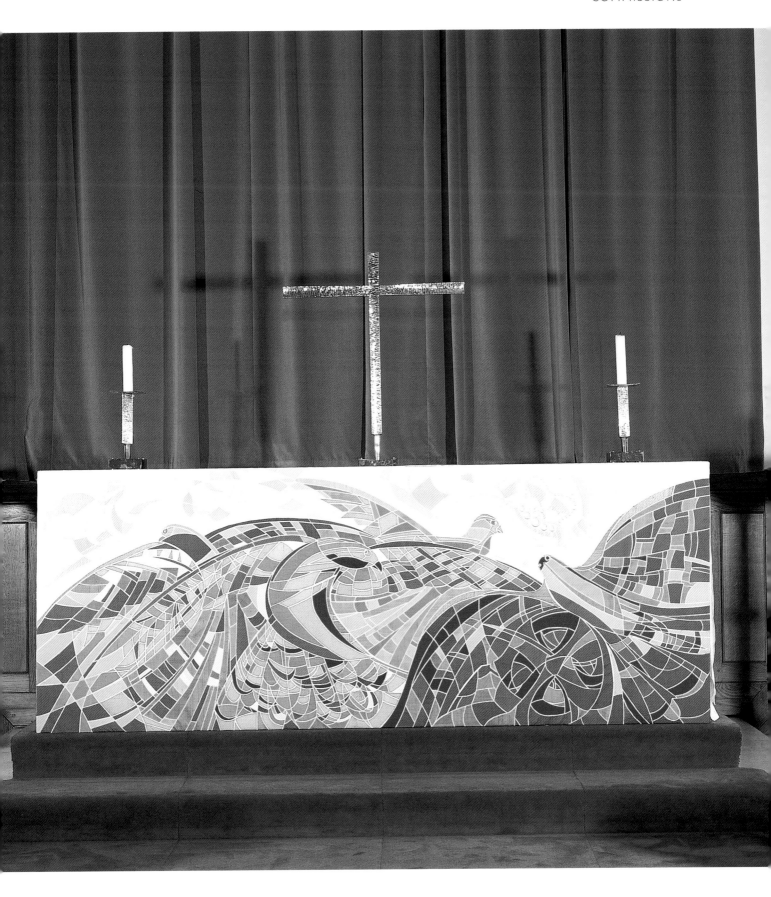

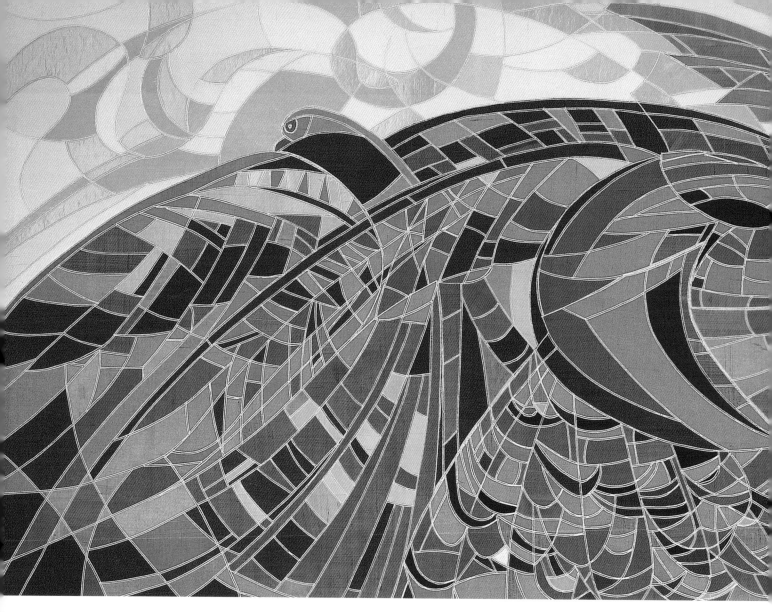

RAF College Chapel Cranwell altar frontal

ABOVE detail of appliqué

LEFT Preliminary thoughts for a design –
pencil drawing

RIGHT Design sheet for *RAF College Chapel
Cranwell* altar frontal

Photos by Dave Hankey

106

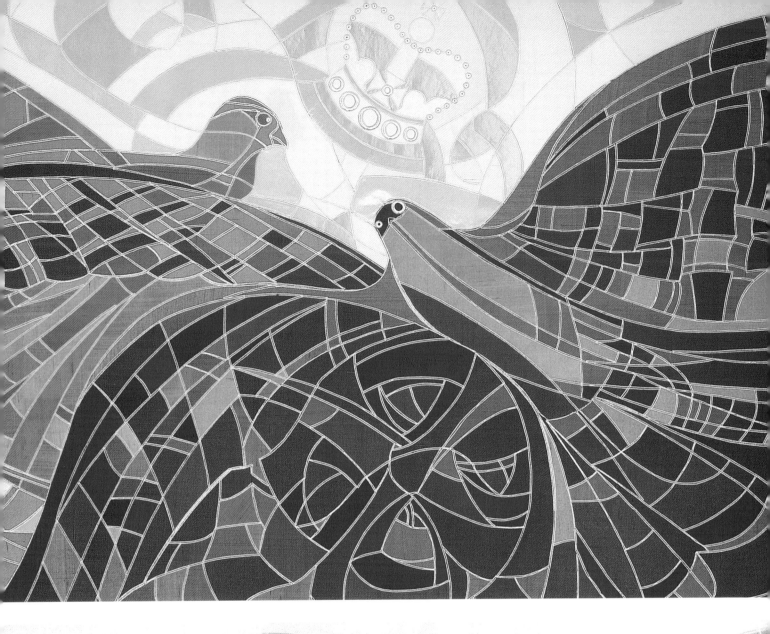

From an unpromising brief, has Diana created a striking contemporary artwork. Exhibited at St Paul's Cathedral in 1990 as part of the Beryl Dean inspired exhibition *British Ecclesiastical Embroidery Today*, the *RAF College Cranwell* frontal attracted many favourable comments and was described in the catalogue as 'not only evoking mortal flight but something of the poetry of Stephen Spender... "And left the vivid air signed with their honour".'

It was Diana's fascination for raised line that came to the fore in her commission for *Logica* in 1991. A business and technology company, Logica were seeking an artist to produce an artwork in memory of Pat Coen their co-founder and director. Having been awarded the contract, Diana used the concept of a circuit board as the basis for the commission: a huge vertical panel that was made for the glazed entrance to Logica's London office and now resides in their new building in Staines, Middlesex.

630cm high by 120cm wide, the work includes a series of personal references to Coen: his birth-date; his initials; his capacity for lateral thinking. Friends and relatives helped stitch each of the twenty-seven sculptural 'resistors' whilst Diana created circuits of 'wiring' from piping cord. The statistics of its making are staggering: 3,780 metres of perle cotton; 1,269 metres of button cord, all hand-sewn; 2,400 metres of machine thread and 650 metres of piping cord.

Scaling-up has never been an issue for Diana, but projects of this size and ambition are beyond the capacity of any one person. Bringing help alongside was vital. For *Chester Today*, the involvement of community groups had been a natural resolution. With the *Logica* panel, the contribution of family and friends had been a form of personal tribute. Where there was a need for additional help but no evident source, Diana would frequently turn to her students and seek their involvement. It was a strategy that benefited both parties. Pat Wright recollects:

Images of computer circuit boards
Photos by Diana Springall

'Diana would invite some of us to help on various projects, both during the time we were at college and afterwards. I had the good fortune to help with the work for Sheffield University Library and other large scale works. By then I was teaching but spent half term and the odd weekend in Kemsing, where Diana not only encouraged me in the work...but also poured out her usual...hospitality. Diana was also generous in passing on work that she could not do alone. She encouraged me to accept commissions for church embroidery saying that I should never turn down work as it may not come along again.'[v]

Never refusing work was a lesson Diana had taught herself. 'I've never turned things down and I've never touted for work. I've always been fortunate and I think its because I've volunteered when asked. So I always say do anything because, even if you're not paid, people will know to trust you.'

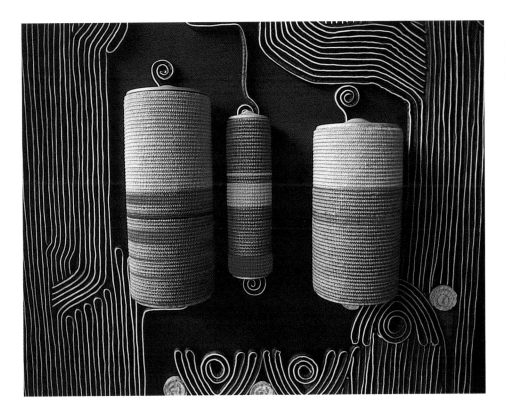

Detail of 'resistors' showing
high relief of embroidery in
gobelin stitch stretched over
sycamore cylinders. Photo by
Diana Springall

Thoughtful in every part of the commissioning process, the detailed research and consultation Diana undertakes is reflected in the positive responses her work has received. 'Every client is still in touch, its been a lovely relationship with every one. People become your friends when they commission you and they're all willing to have you back.'

Achieving that degree of sustained contact is the mark of a successful process, as well as a positive outcome. Yet, alongside the satisfactions there are always the disappointments. 'If you're doing commissions, you have to learn to live with rejection. You have to believe you'll get the job and put the work in, but you won't get every job and you've got to come to terms with why someone's not wanted you. I did one group of designs for a commission that I really needed at the time. I knew the job I'd done was good and fitted the brief, but it didn't succeed. They wanted something else. Rejection is part of life – it's how you deal with it that matters.'

[i] *Church Building*, Autumn 1989 p31 Claire Melhuish

[ii] *Canvas Embroidery*, Part 1 Projects

[iii] *Officespec*, 1988 p106-7, Kate Southworth

[iv] *Officespec*, 1988 p106-7, Kate Southworth

[v] Correspondence with the author, July 27 2010

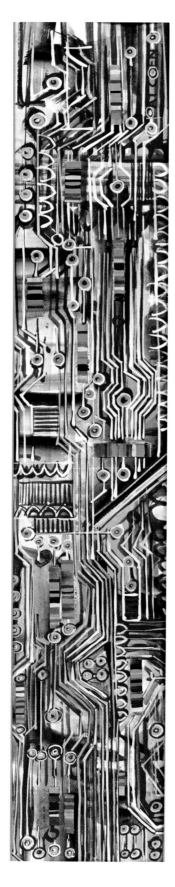
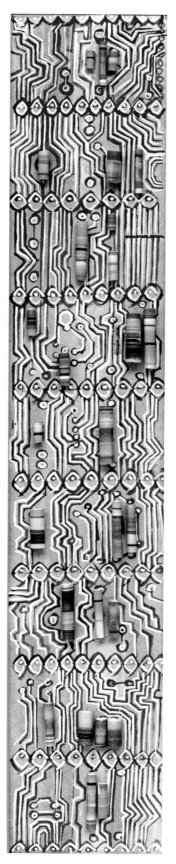
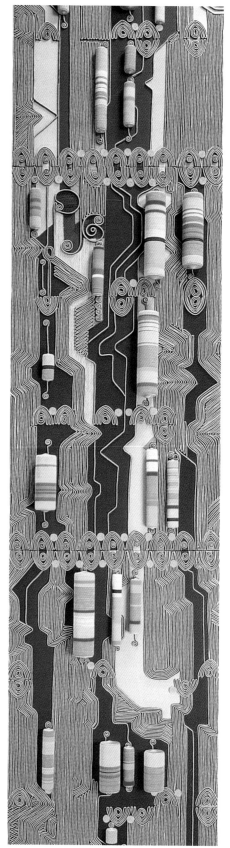

PAGE 110, LEFT TO RIGHT
Logica, Pat Coen Memorial Panel

Gouache design

Gouache design

Detail. Monsa and Lakka fabrics
on denim, combined with hand
embroidery on canvas and applied to
a denim background. The 'resistors'
were embroidered by Coen's relatives
and friends.

RIGHT *Logica, Pat Coen Memorial Panel*

Panel displayed in the entrance hall
of Logica's head office in London, the
panel is a tribute to the company's
founder. The circuit board design
references Logica's business and
personal details specific to Coen
whose initials PJC are visible in the
piping circuitry. Each line of colour
in the central resistor corresponds
to a number which, in sequence,
represent his birthdate. The panel has
since been relocated to Logica's new
building in Staines, Middlesex.
6.30 x 1.20m.

8

Japan

'I respond to Japanese asymmetry and to its more positive balance.'[i]

There are some years that can be recollected with clarity well beyond the moment they drifted into the past. Diana has known several such years in her life. There was 1947 and the move from India to an austere Britain. 1975 brought Oast Cottage and a new beginning. Then, just a short while later came Diana's fortieth year, 1978: the year she first visited Japan and took up office at the Embroiderers' Guild. The timing was coincidental; that all this should take place during the year of a milestone birthday was pure serendipity. The events that occurred were not.

The catalyst for all that would unfold that year was a World Crafts Council assembly meeting in Kyoto. Founded in 1964 out of a desire to 'provide a better future to the craftspersons of the world'[ii], the WCC had established these biennial assemblies as international fora that would inform and stimulate the work of practitioners, curators and advocates across the sector. The Kyoto conference had been promoted as the first to focus on all the crafts and Diana was determined to be present. Aside from her personal interest as a member of the WCC, she had recently been elected Chair of the Embroiderers' Guild and this was an ideal opportunity to unite both roles. It was a prudent and a positive decision. The trip was to prove highly significant for the Guild and would inform Diana's practise for years to come. Personal contact, and that willingness to take on any work, would again play vital roles.

Fumiko Ogita, Osaka, 1985. Photo by Diana Springall

Life Member of the Embroiderers' Guild – now aged 83

'I thought I'd combine work with my visit so I wrote to the Guild to ask if there were any members in Japan. I got a letter back – there was one.' The thought of a single member in an entire country would sink most hearts, but Diana focused on the person rather than the statistic. The contact more than repaid her commitment.

'It was a lady called Fumiko Ogita. She wrote me a letter and said – "I'll be in the hotel lobby when you arrive" – and that's how we met. She'd been coming to London for years to take courses at the Royal School of Needlework with an interpreter. Then after we'd met, I taught her at home by myself – no interpreter at all – when she came to my summer schools. She worked and

ヨーロッパの"刺繍王国"を代表する現代作家12人の名品集。

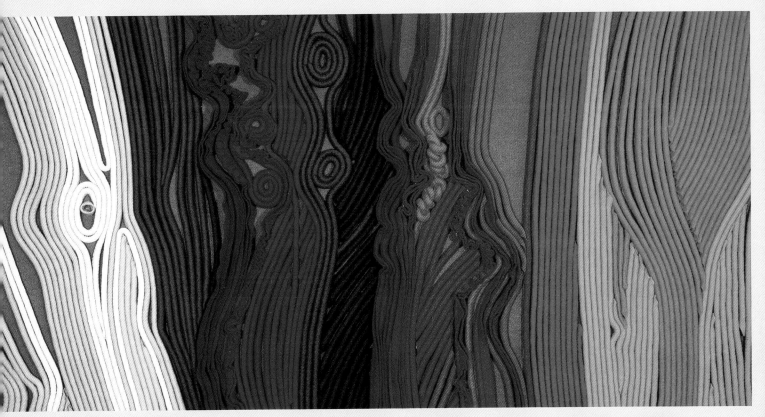

イギリスの現代刺繍

Twelve British Embroiderers 全1巻 英国刺繍協会会長 ダイアナ・スプリンゴル編著 学研

Poster for the *Twelve British Embroiderers* exhibition in Japan

The image is a detail of a panel commissioned for the home of Ann & Ian Joyce in Cowden in Kent (left). Photo by Dave Hankey

taught at Daimaru – they had big department stores in Osaka and Tokyo. All kinds of things happened from that meeting with Fumiko – opportunities just seemed to open up.'

Seizing opportunities takes boldness; maximising their potential requires hard work. Diana was capable of both. If there were appropriate opportunities to be taken, for the textile community or her own practise, she would do all she could to ensure that opportunity would not be lost. The openings that came from that meeting with Fumiko would fill the next seven years of Diana's professional life. This was an expansive and immensely fruitful period, and it was in her work that the first of these fruits came to bear.

Given her life-long love of plants, shrubs and flowers, it was only natural that Diana would seek out the Zen gardens of Kyoto and nearby Nara during her time in Japan. They did not disappoint. She found them inspirational and they almost immediately became the focus for a body of fourteen small textile works.

She delighted in these quietly reflective spaces with their raked gravel, clipped bushes and subtle muted colours. They were aesthetic pleasures; ordered landscapes in which everything was considered and existed in relation to the whole. Spending time in the gardens with their softly sculpted shrubs and gravel lines, Diana could sense the parallels with her own work. They were ideal subjects for her; almost living embodiments of her practise.

Never one to waste time, Diana made the most of her visits to the gardens: sketching and photographing the layouts as well as their component parts. This visual record was a critical stage of her design process and would inform the making of all the pieces she subsequently produced. *The Japanese Garden Series* was exceptionally well received. Most works sold as soon as they became available.

These pieces were quintessential Diana: restrained, meticulous, technically accomplished and visually satisfying. There was something inherent in Japanese design which resonated with her practise: it was that use of shape – of silhouette abstraction – and of positive and negative space.

A fanciful interpretation of this correlation might reference Diana's predisposition towards positivity: that desire to focus on harmony rather than dissonance in life, as well as in art. Whilst this was undoubtedly a substantive factor, here it was her education that carried the greater influence. This was the response of one aesthetic to another: something awakened during Diana's training at Goldsmiths' where she first became aware of Japanese prints and learned of their influence on Art Nouveau. 'I am as comfortable with abstract concept as with shapes and lines and colours that become a subject; in fact, without the former, the latter would have no structure or significance for me.'[iii]

Years of work and several major projects developed from that visit Diana made to Japan. Her friendship with Fumiko was central to almost everything that emerged. The times shared together at Oast Cottage during the summer schools proved particularly influential as each supported the work of the other.

Diana with Fumiko Ogita's grand-children Kazahito and Tamaki taken whilst staying at her Osaka home
Photo by Dr Ogita

Garden in Kyoto, Japan. Photo by Diana Springall

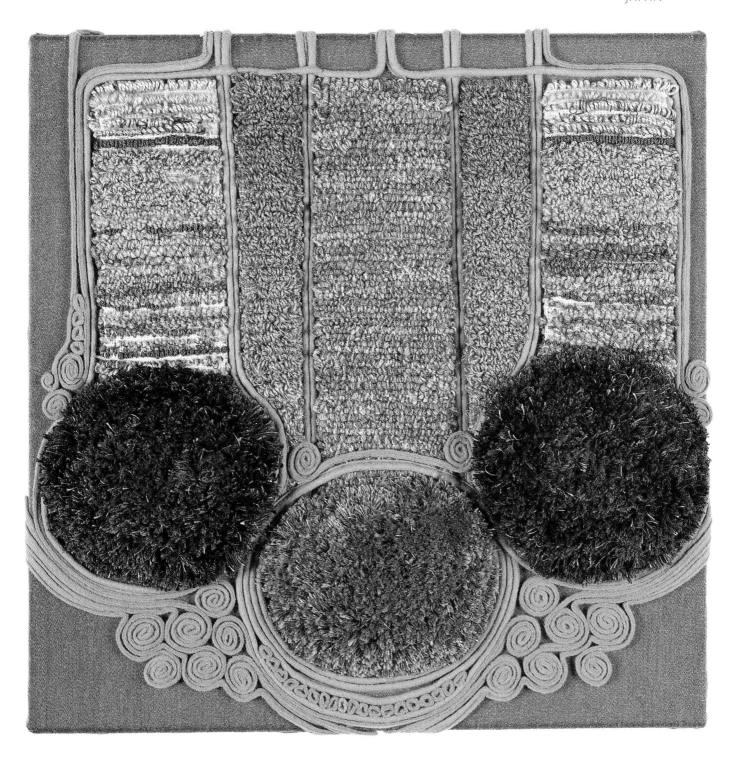

Kyoto, 1984

Low relief in hand loop pile in stranded cottons and wool felt piping, 34cm sq. Collection of Brian & Dawn Alexander. Photo by Dave Hankey

OVERLEAF, PAGE 116
Autumn in Nara (pink), 1986

Low relief in hand loop pile in wool threads and wool piping, 91 x 56cm. Photo by Dave Hankey

PAGE 117
Autumn in Nara (green), 1986

Low relief in hand loop pile in wool threads and wool piping, 91 x 56cm. Photo by Dave Hankey

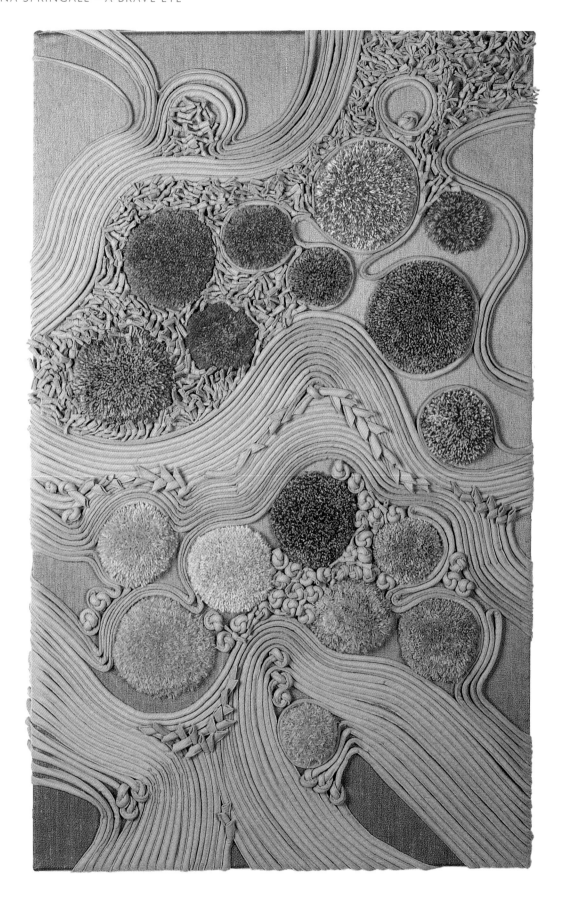

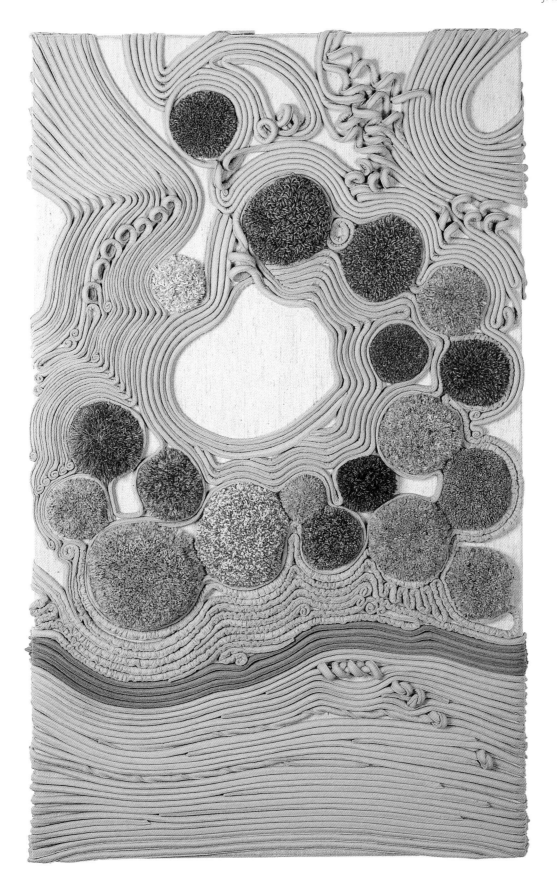

FAR LEFT Diana escorting Her Imperial Highness Princess Chichibu around *Twelve British Embroiderers* 1985 Tokyo

LEFT Fumiko Ogita and her mother at *Twelve British Embroiderers*, Osaka, 1985. Photo by Diana Springall

'It was Fumiko that introduced me to the people at Daimaru. They came to see an exhibition of work by Guild members that I'd been asked to curate at short notice. It was at the Commonwealth Institute in 1980.[iv] They really liked the work and wanted to take it to Japan to show it there, but there was no provision to tour. So, I said give me three years and I'll arrange another. And that's what I did.'

Diana is short-changing herself: she actually delivered the exhibition in 1982, a year earlier than she had initially projected. It was a groundbreaking venture, one of the first to tour British embroidery in Japan. Displayed in Daimaru's top floor gallery, the exhibition opened in Osaka before transferring to Tokyo. The response, particularly to the more traditional embroidery, was overwhelming. 'We sold a lot of pieces – all the whitework just flew off the walls.' By the time the remnants of the exhibition had reached the UK, Diana was already beginning to plan a sequel. When she returned to Japan three years later, it was with *Twelve British Embroiderers*. This time, there was a book as well as an exhibition.

'*Twelve British Embroiderers* came about because of Fumiko. There was very little about British embroidery in the 1980s. People didn't know it existed – they mostly thought of the US. She said I should write a book about it. So she went back to Japan and told them and then I got a phone call from Paris and they sent me a contract. It was just a scrap of paper – but it was a contract.'

Published in English and Japanese, the book highlighted the work of twelve figures Diana considered pivotal to the development of contemporary stitch in the UK. Three stood out above the others. 'There was Kath Whyte from Glasgow and Margaret Nicholson and Beryl Dean with her ecclesiastical work. They were all great pioneers.'

Zen gravel garden, Japan. Photo by Diana Springall

RIGHT *Zen Garden*, 1984
Low relief in hand loop pile in stranded cottons and wool felt piping, 52 x 23 cm. Collection of Tom & Ruth Keesling. Photo by Dave Hankey

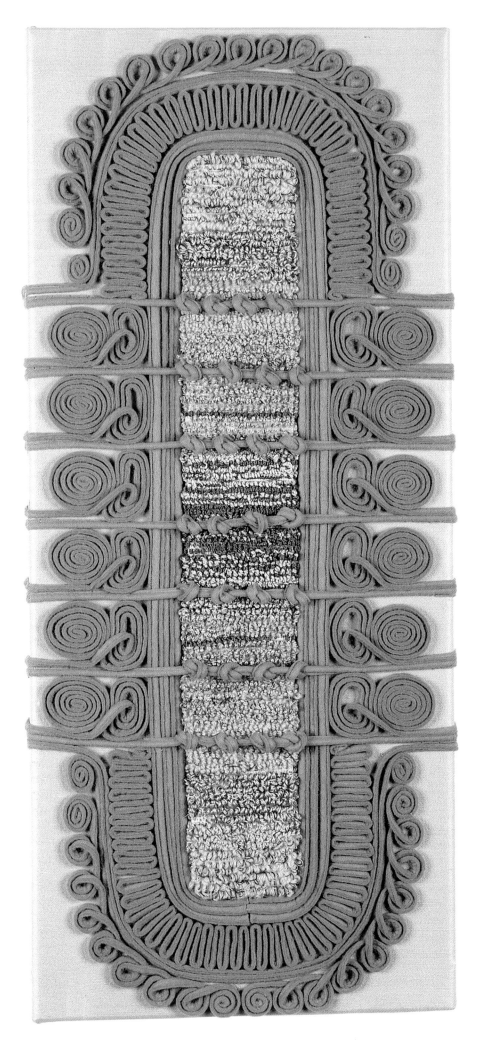

The work of these three plus the other nine selected practitioners – which on this occasion included Diana herself – formed the content of the exhibition. As with the previous exhibition, the work was shown in the two Daimaru stores. The response was equally positive. 'Now the museums and business world took note and purchases were made from most of the artists – the Museum of Modern Art in Kyoto acquired several pieces for their collection. Verina Warren's work was particularly popular and one client commissioned her to produce a piece of work every year for twenty-four years until his death. It was hugely important exhibition for her and for many of the other artists.'

There would be no further exhibitions in Japan after *Twelve British Embroiderers*, but there would be other opportunities. A series of large-scale commissions were to dominate the next few years: *Beryl A Oil Field* for Mobile North Sea and *Graduands* for the University of Sheffield were both unveiled in 1988. Two church commissions followed and then, in 1991, the panel for *Logica*. In the midst of these projects, however, Diana had one further opportunity to draw on her experience of Japan: a commission for the newly built *Dai-chi Kangyo Bank* in the City of London.

The brief Diana had been given was to produce a panel 16.5 metres wide by 6.5 metres high for the bank entrance. The concept for the work had yet to be determined when she made the first of her planning visits.

'I was summoned to the offices...to discuss the work with the Japanese architect – the British counterpart was late. I was left sitting in a vast boardroom struggling to communicate with a bank executive. He spoke little English and I had only twelve words of Japanese. I gathered he wanted to know what theme I had in mind for the work – he thought the River Thames was a good idea. My heart sank – what had that to do with Japanese banking? Eventually, I asked if he could write the name of the bank for me in Kanji – "Kanji, what do you want Kanji for?" Well, one of the other alphabets would do – Katakana – "what for?" Well they are beautiful shapes. I took lessons in Shodo (brush writing). Well, we never looked back – he wrote them time and again in different ways..."If that's what you want I'll get the best calligrapher in Japan to write it for you." This he did and I had twelve versions to choose from – I just had to be sure which was top and which was the place to start!'[v]

It is a gently comic anecdote that illustrates Diana's quiet firmness and determination as well as her wry sense of humour. There is little ego, however. Her approach is entirely collaborative – always consulting and working with others to achieve the best possible outcome.

Throughout the Dai-chi Kangyo Bank project, she worked closely with both the Japanese and British architects involved in the building's development. Their response to the space informed her own. 'I saw they were giving vertical emphasis to the walls with the slim ribs of [pink striated marble] different from the rich cream Carrara which is their principal material and that made me decide to divide my design vertically into three.' The completed panel is a monumental

Entrance Panel, Dai-ichi Kangyo Bank, 1989.

Low relief in loop pile in wool and piping in Lakka fabric, 1.85 x 4.9m

In 2004 DKB was absorbed into Mizuho Corporate Bank and the piece now resides in their art store

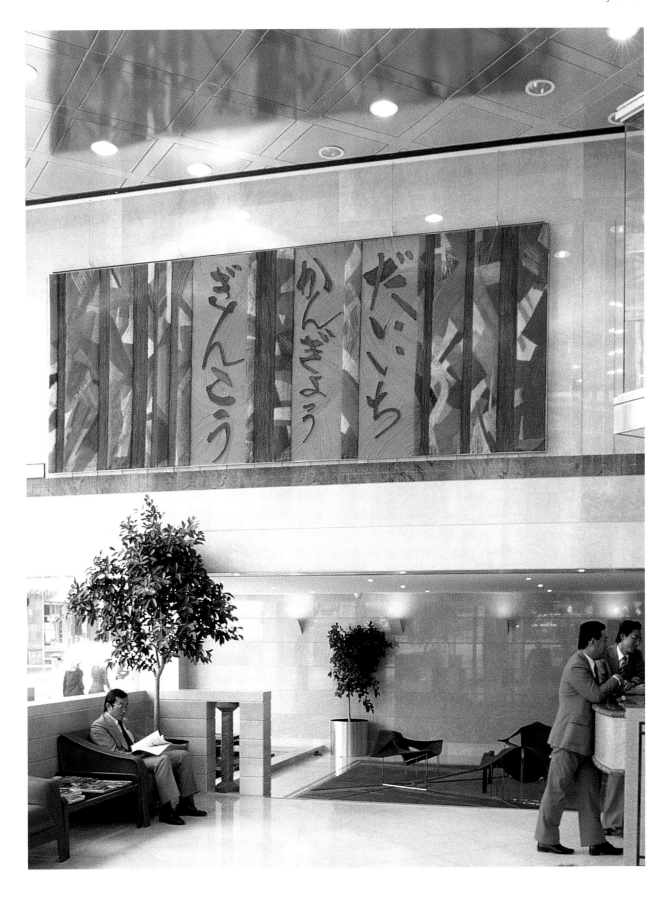

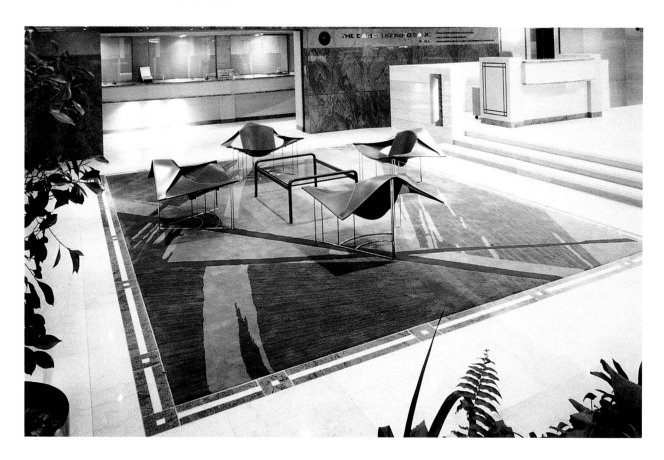

Carpet, Dai-ichi Kangyo Bank, London, 1989

Loop pile, tufted, Tactesse yarn. 5.8 x 4m

work, positioned high on the wall above a horizontal line of contrasting marble. The calligraphic text fits perfectly within the vertical forms which also reference Zen gardens and the colours of a rising sun.

That visual and spatial awareness, combined with her eye for detail and intense practicality are attributes that Diana brings to every commission. These qualities inform not only the aesthetics of the design but also its appropriateness to the needs of each particular context. The Dai-ichi panel would be on open display in a busy reception area. Aesthetic sensitivity and physical care were both important considerations. 'I used pink plastic tablecloth material from John Lewis...It looked not unlike fine Japanese lacquer work – it wasn't my intention but it was lucky. My intention was that it was wipeable!'[vi]

[i] *International Textiles Interiors*, 1988 p72, Trevor Gett

[ii] http://www.worldcraftscouncil.org/

[iii] *World of Embroidery*, July 1999 p224

[iv] 'Before the 1980 Guild exhibition at the Commonwealth Institute [Diana] virtually left her hospital bed to hang the exhibits simply because there was no-one else available.' *Embroidery*, Summer 1985 Volume 35 Number 2, Elizabeth Benn

[v] Diana Springall lecture notes

[vi] Diana Springall lecture notes

RIGHT *Dai-ichi Kangyo Bank panel* detail. Photo by Dave Hankey

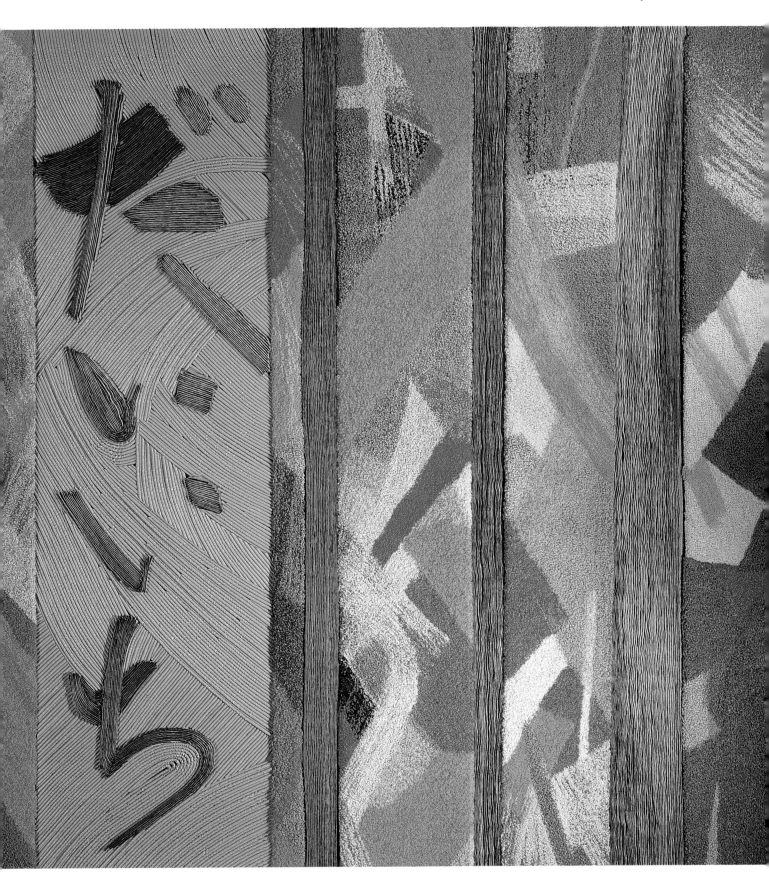

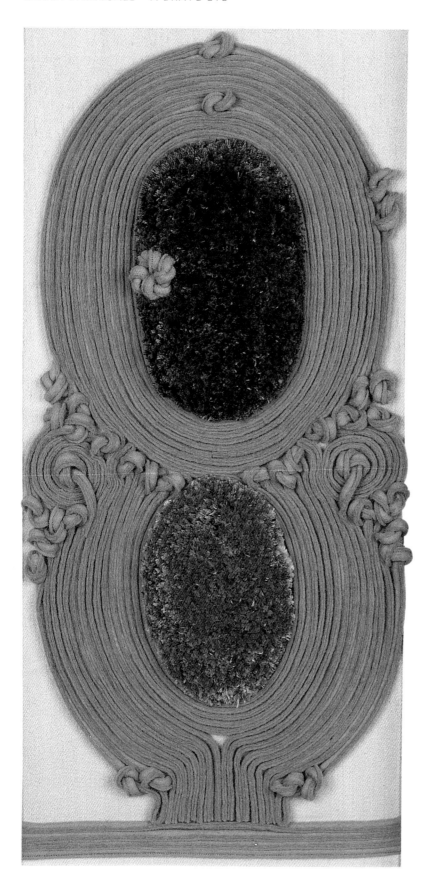

LEFT *Ryoanji*, 1984
Low relief in hand loop pile in stranded cottons and wool felt piping, 40 x 19 cm. Photo by Dave Hankey

RIGHT *Tatsumi-naka*, 1984
Low relief in hand loop pile in stranded cottons and wool felt piping, 49 x 44cm. Collection of the Embroiderers' Guild, purchased by Michael Langlay-Smith. Photo by Dave Hankey

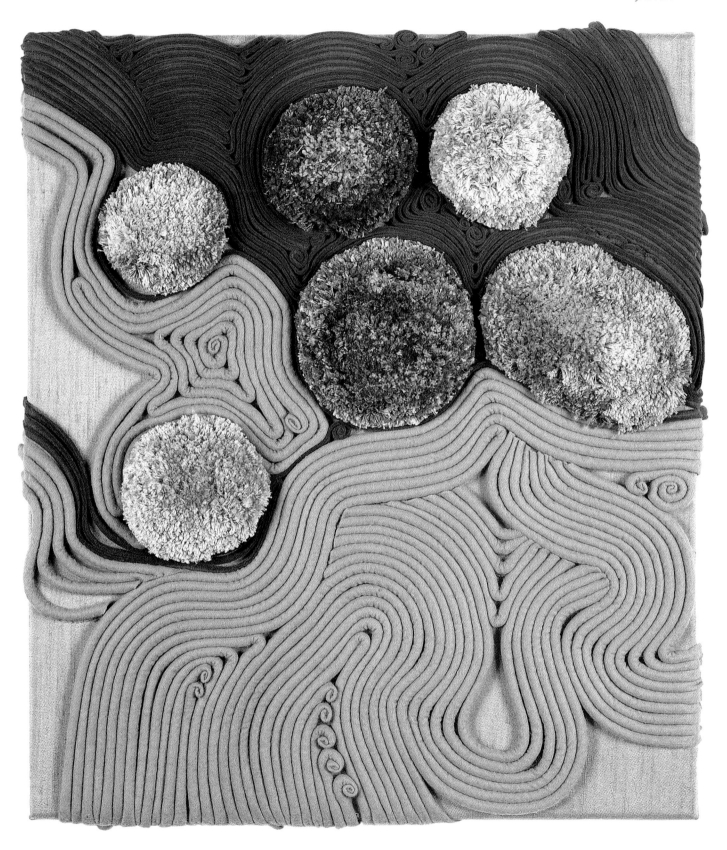

9
Advocacy

'I still bat strongly for the world of embroidery.'

It would be inaccurate to say that embroidery is Diana's life. There is so much else that is of concern to her – people above all else. However, it would be fair to say that she has devoted her life to the practise of needle and thread. Stitch is something that has positively consumed her energies since childhood. Reflecting on that lifelong commitment to embroidery, it is revealing to note precisely how much of that energy Diana has focused on the field as a whole. At times, this has been to the detriment of her own practise. This is not something that is a matter of regret for Diana: it is something she has relished.

'There is,' explains Mandy Carr, 'an integrity about Diana as a person and what she offers to others. She never comes empty handed – and whatever she gives, she gives with an open hand.'[i] Mandy is speaking from her personal experience of Diana as a maternal figure who became a friend. Someone who would never think of visiting without bringing some flowers from the garden, or a piece of home-baking. Someone who would share themselves with you, wherever you happened to be.

That generosity of spirit – a willingness to give of oneself – is another of Diana's defining characteristics. It is a personal attribute that has informed her entire professional career; and it is this quality that has led to her dedicating significant periods of time to work beyond her own practise. Diana is, first and foremost, an advocate for needle and thread.

Advocacy was a role Diana naturally assumed rather than one she actively pursued. The promotion of stitch has been integral to her work since those early days as a teacher, when she would encourage students to study historic and contemporary embroidery in order to stimulate their own practise. It was an approach Diana had benefited from herself and one she delighted in sharing with a wider audience when given the opportunity to write about it for a book.

'Constance Howard asked if she might include *Three Flowers* as an illustration in her book *Inspiration for Embroidery* which was published by Batsford in 1966. Later, the editor Thelma Nye invited me to do a book on canvas embroidery.

PAGES 126–127
Poppy Fields near Knockholt, Kent
Gouache painting. Photo by Simon Olley

I declined politely saying that this was my first piece in the technique and that I couldn't possibly do it. She replied that she would be the judge of that and asked for some specimen drawings and a synopsis – the result of which I found myself with a contract!'

The book that came from that surprise contact was *Canvas Embroidery*. It was the first of six significant publications Diana would produce over the next forty years. Each would take a slightly different approach, but all were intended to increase understanding of contemporary embroidery and encourage its practise.

The first two books were practical guides that combined technical information with ideas for creative expression in stitch. The approach taken was that which Diana had learned at Goldsmiths': the application of fine art concepts to the medium of embroidery. It was a subject close to her heart, and one she would develop further in her 1988 publication *Design for Embroidery*. Diana held little back in this book which illustrated how ideas could be developed by explaining the creative process she herself used. She explained the significance of this decision in an interview that preceded the book's launch: 'This sort of approach is unusual – designers are, I think, a little wary of giving away such detailed information about the early stages of a work. What I am trying to do is show anyone who's interested how to use their imagination transferring something they've seen – a stained glass window, a bunch of flowers – into an embroidery work.'[ii]

Design for Embroidery, she was to explain later 'is a breakaway because at last I've been able to show how I do a design, not just the materials and then the finished product with nothing in between.'[iii] Diana was not precious about her work or the methods she used. She was quite willing to share all she knew if that would help the development of others. Equally, she delighted in drawing attention to the outstanding work of her peers. That was the remit ascribed to *Twelve British Embroiderers* which was published in 1984 as part of her venture in Japan. This was an innovative book: one of the first to present detailed information on the work of contemporary practitioners. As such, it set a precedent for a wealth of subsequent publications including *Inspired to Stitch*; Diana's own sequel which documented the work of a further twenty-one British textile artists and was released in 2005.

These publications represented a considerable commitment for Diana. She researched their contents, identified images and wrote the bulk of the text in her office at home. 'Instead of a dressing table I've got three filing cabinets of embroiderers lives with my hairbrush on top.' *Twelve British Embroiderers* alone took six months to complete and, aside from her time, the books also represented a considerable financial investment. 'People think you make a lot on books but you don't.' That Diana continued to publish over four decades is a testament to her passion for embroidery. It seems entirely appropriate, therefore, that a book formed part of the project which enabled Diana to share this passion with her largest public audience.

Jan Beaney and Diana Springall. Image
taken from BBC2 *Embroidery* 1980

In 1980, BBC2 televised a series of ten programmes on embroidery. Each episode lasted twenty-six minutes and introduced the viewer to specific techniques. Appliqué, patchwork, quilting and embroidery were each demonstrated in the studio by artists who included Jan Beaney, Sue Rangely, Julia Caprara, Pauline Burbidge and Anne Morrell. Viewers were shown how to work with a sewing machine as well as by hand and were encouraged to develop their own design projects. The programme was hugely popular and this was reflected in the sales of *Embroidery*, the paperback book which accompanied the series. So great was demand for the publication that it reached eighth position in the complete best-seller list. The impact of the project was immense and the reverberations were felt for some time as the programme continued to be broadcast in other European countries.

Although Diana did not feature in every programme, she had been the catalyst that brought about the series and continued to act as consultant to the BBC throughout the project. Jan Beaney recalls her own experience of being involved:

> 'I came onto the BBC series after it had already been initiated by Diana and the producer. I received a phone call and was asked to lead on the design element and present the programmes with Diana joining me to cover certain techniques. Diana led on the publication with me making some contributions. Diana didn't hold onto the project – others might have found that hard but she was very welcoming. We worked really well together and have been friends ever since. The series had very good viewing figures despite being on at 7pm which was a difficult time for women with families. Lots of women said "if we'd not seen that, we'd not have joined the Embroiderers' Guild".[iv]

That ability to let go – to not be proprietorial or possessive – is an invaluable asset for any advocate. It allows the focus to shift naturally from the person to the business at hand without the complication of self-interest. Whilst Diana might see herself as 'a typically tetchy Virgo – typical,' there is never a hint of temperament in any of her dealings. Her demeanour is always that of

the consummate professional. It is a trait that paid dividends with the BBC project and one that equipped her well for the organisational work she would undertake.

Diana has an acute sense of societal duty. This is reflected in the numerous professional roles she has fulfilled during her career for organisations that have included: The Society of Designer Craftsmen; the Royal Society for the Arts and the V&A. Her most enduring contribution, however, has been that made to the Embroiderers' Guild.

'I believe passionately in something like the Embroiderers' Guild,' she explains. It is no empty statement. Diana has been an active supporter of the organisation over many years, as Jan Beaney recounts;

> 'I first knew Diana in 1975-6 when the Embroiderers' Guild was just two rooms in Bolton Street after having to leave Wimpole Street. At that time, the Guild would not have survived without Diana's and Lynette de Denne's vision and belief for its future. This led to the Guild moving to Hampton Court Palace and the Guild went from strength to strength. As a young graduate and member of the recently formed 62 Group, I had served on the Executive Committee chaired by Lady Hamilton Fairley in the 1960s. In the late 1970s, I was invited to serve again under Diana's chairmanship and this experience was very different. Diana was much more involved and hands on and the Guild successfully developed and widened its scope. Diana has always been enormously supportive of the Guild, including during the difficult times. She is ever so loyal, warm and works very hard. She is always there at exhibitions – and she doesn't let personal difficulties affect her professional work. She has been a great friend to the Guild as well as to me.'

The Guild was experiencing one of its more difficult patches when Diana was called on to help. She did not disappoint. Appointed Chairman in 1978 – with Anne Morrell a supportive Vice Chair – Diana held office for seven years. It was not an exceptionally long period of tenure but it was sufficient for Diana to transform the Guild's fortunes, as she first consolidated the organisation and then began a programme of expansion. That visit to Japan was just one of many projects Diana initiated as she looked to establish the Guild on a surer footing. New premises were found at Hampton Court, additional members recruited and a trading section formed to generate revenue.

Diana led by example and where she lead, others followed. Her student Pat Wright was one of the many who responded.

> 'Diana's role with the Guild was such that I also wanted to become involved and after she introduced me to Lynette de Denne, I found myself starting the Bromley Branch. She was so enthusiastic and supportive...I remember her giving our first talk. Ten years later she was invited back to celebrate their birthday and present another one.'

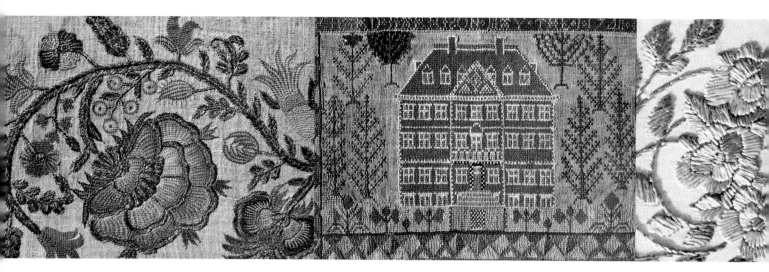

Branch visits, presentations, the BBC programme, acquisitions for the collection, exhibitions in the UK and overseas: Diana was active in every part of the Guilds' work. Her efforts were untiring and they were handsomely rewarded. By the time her term of office came to an end in 1985, the Guild was a flourishing and confident organisation. A formal letter of thanks sent to Diana shortly after her departure acknowledged the extent of the contribution she had made:

'Thanks for being such a wonderful chairman. You gave up so much of your valuable time to steer the Guild back to "life" and to get it established at Hampton Court. I doubt if 8 years ago any of us would have envisaged just how fast the organisation would grow and for this expansion and its prestige in the eyes of the outside world, you must take a lot of the credit. I know that Guild activities have greatly curtailed the physical output of your own creative energies and now that you are free to concentrate on these we all look forward to seeing a spate of stunning work...We all wish you every success in this new phase of your career and will always be extremely grateful for all you did for the Guild.'[v]

Of her role as an advocate, Diana has said 'I have never sought these things and I am sure I fell short in a lot.' There has been no mention of shortfall from those with whom she has worked.

[i] Interview with the author March 3rd 2010, see also Chapter 5

[ii] *Sevenoaks Chronicle* February 6th 1987

[iii] *Home and Freezer Digest* June 1988, Carol Bullen

[iv] All quotes from a telephone interview with the author, August 4th 2010

[v] Personal correspondence to Diana Springall, May 30th 1985 sent by Elizabeth Benn

ABOVE AND BELOW *Calendars* – designed to be tear-off post cards

'Throughout my Chairmanship of the Guild I photographed items from the collection for calendars, cards, tea towels etc. Branches pre-ordered after the AGM and Diana Keay masterminded the print order, the storage of stock and delivery to the regions. Merchandise was popular, profitable and successful.'

10

Collection

*'I continue to champion for embroidery which uses needle and thread...
to express the discipline of art.'[i]*

There has been much discussion in recent years on the position of textiles as an artform and its profile relative to other disciplines.[ii] That debate has proved to be as complex and multi-layered as the medium on which it is centred. Amidst the variety of concerns and approaches that have been aired, however, a number of commonalities have emerged. At the heart of these is the observation that whilst the medium has changed significantly in the past sixty years – sparked in part by its recognition at NDD level – external perceptions of what constitutes textile practise have continued to lag behind the reality of all that is taking place. It is as if the field has grown beyond the boundaries within which it is expected to operate.

Several factors have been identified as being responsible for this gap in understanding. The lack of venues dedicated to textile practise; the concomitant problems of programming; the need for critical writing beyond niche publications and a paucity of collectors of textile art, have all been listed as contributing to the current position. Put simply, practise needs to be visible in order for people to know it exists – it needs to be before our eyes. Public exposure to the breadth and depth of contemporary practise is vital to the process of extending awareness of textile art and the context in which it sits.

Diana's work in this area has been remarkably prescient. Throughout her career, she has actively promoted textile practise beyond the parameters of its traditional audience. It is a thread that runs through so much of her work: the community projects and public art commissions; the BBC series and the 1976 event at the V&A; the 1982 exhibition in Japan; her involvement as an artistic pioneer at the Knitting and Stitching Show; her publications. There are so many occasions when Diana has been the first to grasp an opportunity or to take a risk. Her fifty years of practise have been ones of quiet innovation. It is therefore little surprise to note that she is one of the few who purposefully collect contemporary textile art.

The motivation of any collector is often as revealing as the material they acquire. Some will collect for personal pleasure, some to document a field; others as an investment or to leave a legacy. The reason Diana collects is entirely

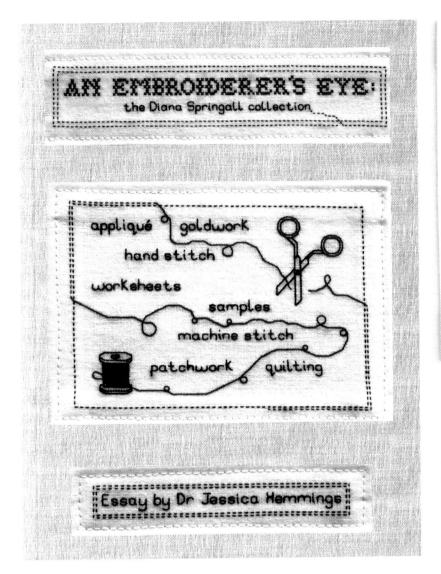

AN EMBROIDERER'S EYE:
the Diana Springall collection

appliqué goldwork
hand stitch
worksheets
samples
machine stitch
patchwork quilting

Essay by Dr Jessica Hemmings

Jeanette Appleton Karen Armistead Helen Banzhaf
Jan Beaney Natalie Beavis Richard Box
Elizabeth Brimalow Pauline Burbidge Julia Caprara
Mary Cozens-Walker Tania Cuthbert Sarah Denison
Isabel Dibden Emma Dillon Louise Gardiner
Caren Garfen Robin Giddings Morag Gilbart
Deirdre Hawken Nicola Henley Charlotte Hitchon
Hilary Hollingworth Theresa James Claire Knight
Helen Kenyon Alice Kettle Sarah Lawrence
Jean Littlejohn Jae Maries Sally Marsh
Laura McCafferty Jane McKeating Eleri Mills
Anne Morrell Carol Naylor Margaret Nicholson
Kerry Pilkington Belinda Pollit Jane Poulton
Rachel Quarmby Sue Rangeley Holly Reece
PrinKie Roberts Alison Rogers Joanne Satchel
Eirian Short Rachel Setford Laura Sharp
Ruth Tudor Audrey WalKer Juliet WalKer
Verina Warren Kate Wells Cheryl Welsh
Dianne Westmoreland Paddy Killer

LEFT Caren Garfen commission for front cover
of *An Embroiderers' Eye*, 2008/9
Hand embroidery in silk on an even weave
cotton ground, 20 x 12cm and 11 x 9cm

Detail of back cover, right.

Photos by Simon Olley

consistent with the rest of her practise. She collects to encourage and support contemporary embroidery.

> 'I started collecting to stimulate my students. Also, so I could respond to a question – if someone asked "what do you mean by embroidery" – I could put an exhibition on the wall and prove it.'

Diana made her first acquisition in 1964. She was then only three years out of Goldsmiths' and teaching at Maidstone. The piece she acquired was by Suzanne Armitt: herself then a student at Goldsmiths'. Diana would go on to collect work by many distinguished figures in contemporary textiles but her priorities were evident from that initial purchase. Her selection would always be based on her personal response as a teacher and practitioner to the piece before her. It mattered not whether it was the work of an eminent artist or an emerging student. What did matter was that the piece should demonstrate outstanding practise in the

use of needle and thread and that it should possess the qualities she valued most: materiality, visual awareness, technical accomplishment, beauty, harmony and a concern for detail.

The purpose of the collection was twofold. First and foremost, it would be a didactic resource; something Diana could reference when discussing embroidery as an artform. Secondly, it would be a means by which the practise of individuals could be documented and supported. Whilst the former had been the initial motivating factor, it was the latter that would become an increasingly influential aspect of Diana's collecting.

Jan Beaney, from whom Diana has purchased several works, explains more:

'Diana has always supported collectors and other artists. She has been a terrific influence on increasing awareness that embroidery wasn't just chain-stitch. She is someone who believes observation and research are pre-eminent in whatever medium they work. She recognises and values that in her own work and in other people's. She has always been very supportive of me as an artist and I am very grateful.'[iii]

Jan is one of many who have benefited from Diana's patronage. The list of names is a litany of those involved in extending embroidery practise during the past fifty years. Alice Kettle, Audrey Walker, Margaret Nicholson, Pauline Burbidge, Eirian Short, Jeanette Appleton and Julia Caprara are just some of the artists whose work Diana has acquired.

It is an impressive body of practise to have been assembled in one archive: one that not only represents a range of approaches to stitch, but also documents the development of ideas through a series of designs of paper. That this all forms part of one private collection is impressive; for that collection to have been personally funded by a fellow practitioner, specifically for the benefit of others, is exceptional.

Perhaps even more significant than the content and function of the collection, however, has been the form of its patronage. Whilst the collection is dominated by the work of established makers, many of those exhibits were purchased at a formative period in the artist's career. For each of these individuals, that acquisition by Diana represented an investment in their personal practise. It was a source of encouragement and support at a pivotal time in their career: it was something that made all the difference.

Every year since that initial purchase of Suzanne Armitt's work in 1964, Diana has attended the Degree Shows of various art colleges. Eager to keep abreast of developments in the field, she has actively sought out emerging talent. When it has been found, it has also been encouraged. 'There is,' explains Andrew Salmon, 'that quiet way that Diana moves in the background helping young artists with a strategic purchase or the generous use of her extensive contacts.'[iv]

Alice Kettle is just one of those who has benefited from this support. *Eve Falling from Grace* was purchased at the outset of her career in 1986, as she came to the end of her postgraduate studies at Goldsmiths'.

Suzanne Armitt, *Landscape*, 1961
Low relief of padded silk patchwork with hand embroidery, 25 x 19 cm. Photo by Simon Olley
'*A fellow student on the ATC course and my first purchase of contemporary embroidery on leaving college.*'

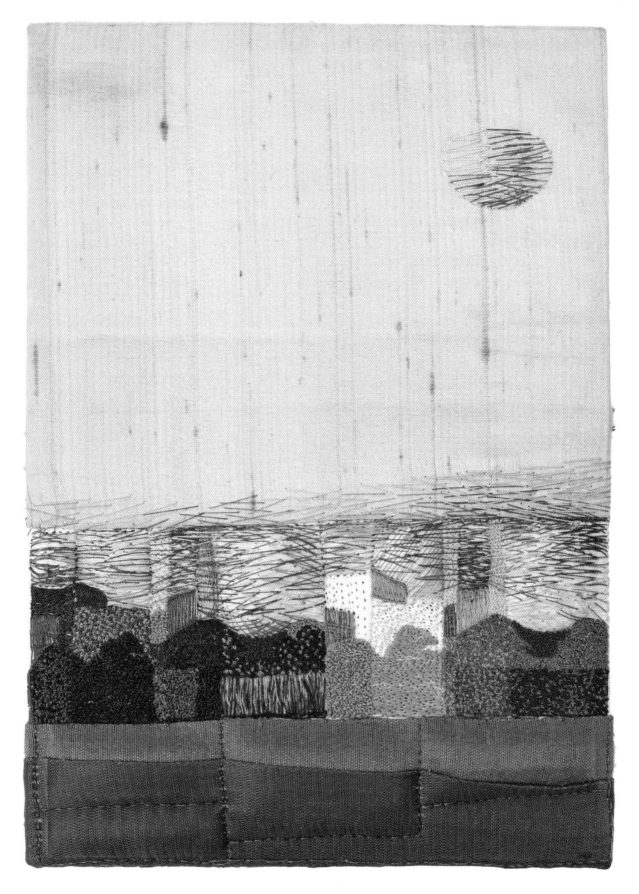

Caren Garfen is another who, more recently, has experienced Diana's support of a nascent career.

'Diana's impact on my life as a "fledgling" textile artist was immeasurable. I was exhibiting at the *Knitting & Stitching Show* on the *Graduate Showcase* in 2007 when I was first introduced to her. Diana made a huge impression on me as she was kind, generous in spirit and very encouraging, so when she contacted me early in my career for a commission I was truly honoured. She had immense faith in me, leaving the complete design of the full cover of her book *An Embroiderer's Eye* [v] in my hands. This has given me great confidence in all of the textile art that I have created since and I have made a special friend too.'[vi]

There are two elements that make the Diana Springall collection such a valuable resource. The first is that experienced by Caren – the support its patronage has given to so many artists at a crucial period in their career. The second is the time during which it has been established. Diana has actively collected material throughout her career. That career has paralleled a period of significant development in textile art. Diana has not only experienced that change herself, she has acquired work made whilst that flux was taking place. The result is not a definitive record of practise – the approach is too consciously subjective for that – but rather an insightful contemporaneous response to textile art. It is a significance best described by Dr Jessica Hemmings, Head of Context at Edinburgh College of Art, in her introduction to *An Embroiderer's Eye*.

'The Diana Springall collection provides a crucial contribution to modern textile history through the representation of work made with needle and thread in Britain from the mid-1970s onwards. As a collector, Springall has moved against the norms of the times, collecting with discipline, place and time very firmly in the forefront of her mind. The result provides us with a considerable record of recent material culture in stitch, a collection that may not have materialised if it had allowed itself to be defined by more mainstream collection policies.

...It is vital to remember that many of the familiar names that make up this collection were individuals at the very beginning of their careers when Springall first acquired examples of their work. This foresight and confidence in careers that, in many cases, were taking their very first steps when Springall began collecting their work, is indicative not only of her visual acuity, but also her confidence and commitment to modern embroidery. In more than one instance, this collection policy is known to have bolstered flagging spirits of individuals, who have gone on to establish professional careers in textiles. Thus this collection stands as a testament not only to an observant, but also a brave eye. The collection that now exists is the result, in equal measure, of instinct and intellect.

Alice Kettle, *Eve falling from Grace*, 1986

Machine embroidery on a calico ground. Purchased from her MA show – it remains one of Alice's seminal works. 233 x 157cm. Photo by Dave Hankey

Springall's collecting does not dwell on [the subversive stitch] in a popular sense.[vii] But I would like to suggest that as a collection, it engages with an equally controversial policy, not through feminism, but in its simple refusal to disregard what may otherwise have been overlooked. It is crucial when understanding this work to bear in mind discipline, place and time. The Diana Springall collection represents work from several decades in modern embroidery's recent history that did not receive mainstream attention at the time of their creation. Today, they act as reminders of a number of individuals who chose, and have continued, to work with materials and ideas that communicate a range of emotions and themes. Looking back now it is refreshing to see that none of these works drown us in conceptual thinking, nor do they need chapters of theory to untangle their meaning from their materiality. Instead, they are explorations of all that thread, stitch and cloth capture and communicate best: colour, texture and pattern; joy and sorrow; labour, concentration and skill.[viii]

Diana's collection is, in effect, an embodiment of her life and practise: it is the fruit of a brave and independent eye.

[i] *The Art of Embroidery*, Diana Springall lecture notes.

[ii] See www.contextandcollaboration.com

[iii] Correspondence with the author August 8 2010

[iv] Correspondence with the author September 7 2010

[v] *An Embroiderer's Eye: The Diana Springall Collection* was published in 2009 to accompany an exhibition of the Diana Springall collection at Macclesfield Silk Museum. It includes details of the collection and a contextual essay by Dr Jessica Hemmings.

[vi] Correspondence with the author, July 26th 2010

[vii] the subversive stitch, in which Rozsika Parker famously noted an inherent duality in embroidery, as 'a means of educating women into the feminine ideal, and of proving that they attained it, but has also provided a weapon of resistance to the constraints of femininity. *An Embroiderer's Eye*, Dr Jessica Hemmings, p8

[viii] *An Embroiderer's Eye*, Dr Jessica Hemmings, extracts from the introduction p7-9

Anne Morrell, *Squares*, 1970

Velvet ribbon, braid, hand embroidery
(raised chain band) and buckles on a felt
ground, 38 x 48cm. Photo by Simon Olley

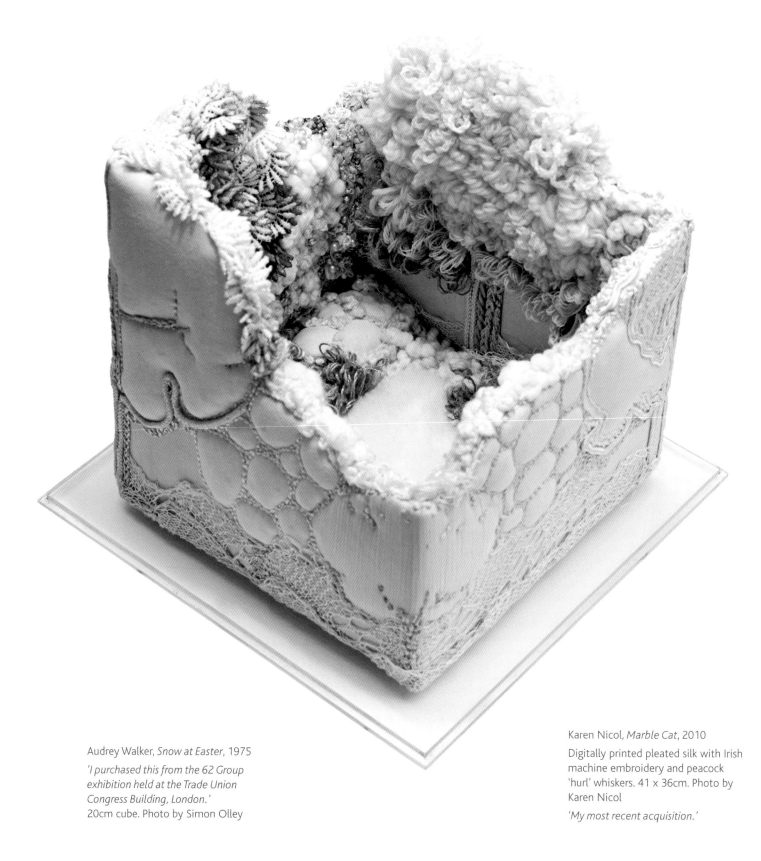

Audrey Walker, *Snow at Easter*, 1975
'I purchased this from the 62 Group exhibition held at the Trade Union Congress Building, London.'
20cm cube. Photo by Simon Olley

Karen Nicol, *Marble Cat*, 2010
Digitally printed pleated silk with Irish machine embroidery and peacock 'hurl' whiskers. 41 x 36cm. Photo by Karen Nicol
'My most recent acquisition.'

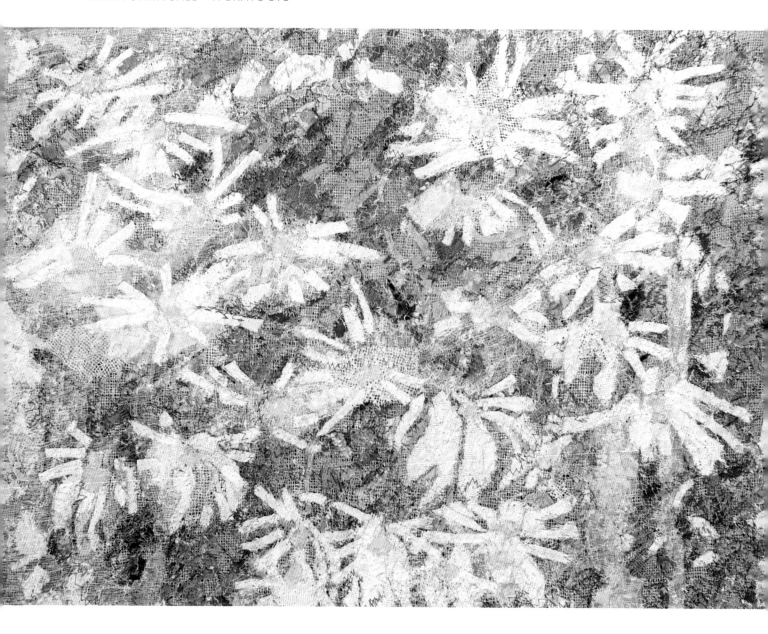

Richard Box, *Daisies*, 1985

Appliqué using random machine zig-zag stitching securing various fabrics on to a hessian ground, 55 x 72cm. Photo by Simon Olley

Kate Wells, *The Rose Arbour*, 1985

Accession note: *'Purchased from her on 21.3.87 after a most pleasant visit to her home in Stannington, Sheffield.'* 37 x 30cm. Photo by Simon Olley

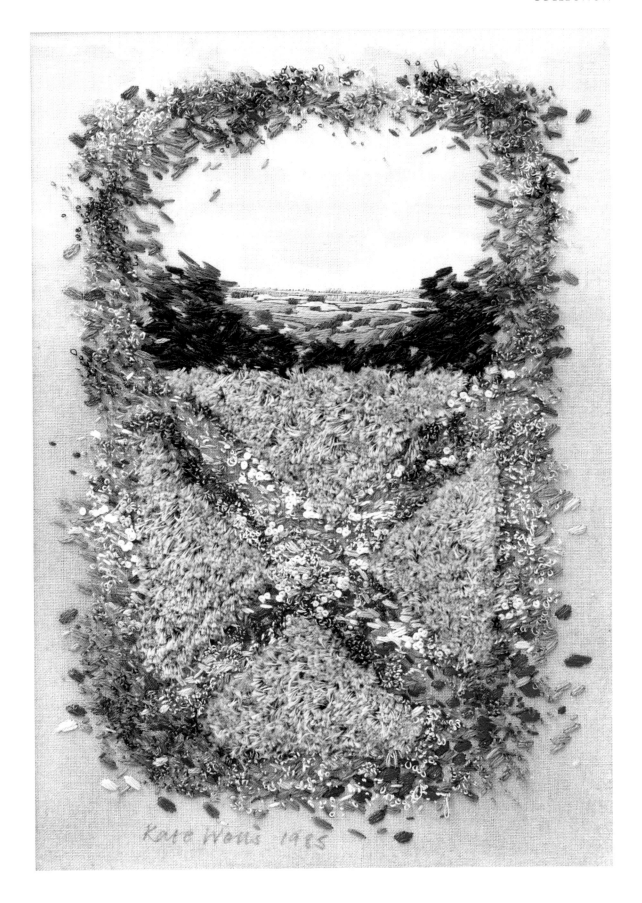

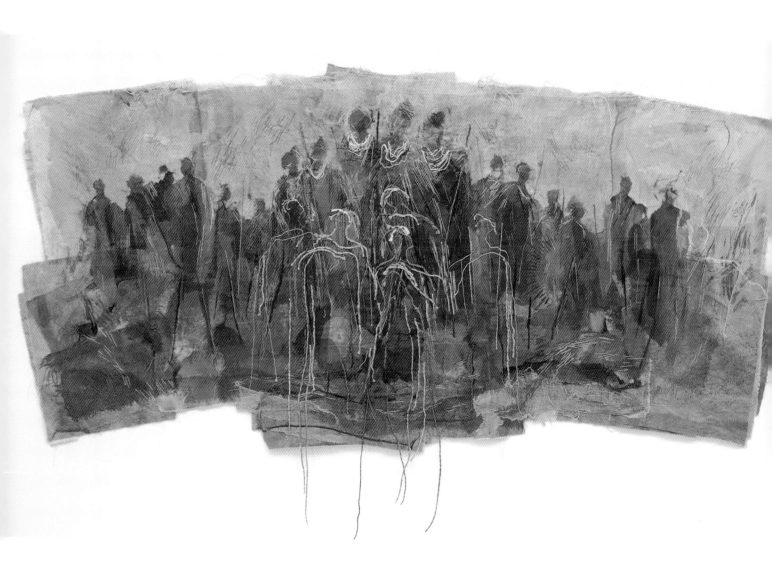

Prinkie Roberts, *All Together*, 2008
Hanging, hand stitchery on applied
layers of many fabrics including calico
cotton, some hand painted, on an
even weave linen ground. Irregular
shape but at largest 60 x 128cm.
Photo by Simon Olley

Eleri Mills *Yr yr ardd (In the Garden)*,
2008
Hanging with painting on cotton with
hand stitching. 129 x67cm. Photo by
Simon Olley

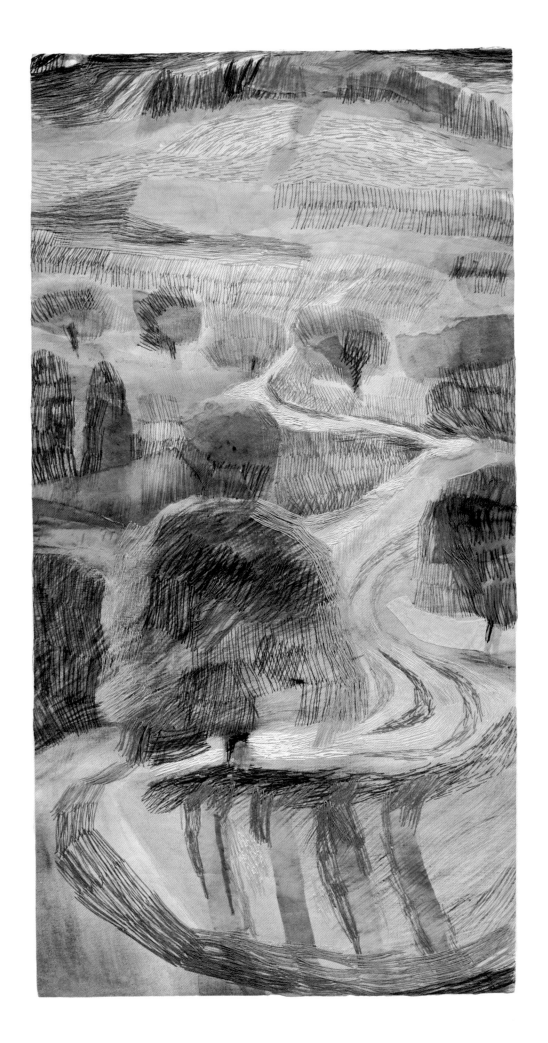

Eirian Short, *Mandala*, 1991
Pencil drawing, one of a series for the final stitched work, 42cm diam. Photo by Dave Hankey

Audrey Walker, *Drawing*
Graphite, crayon and pastel on tracing paper, 74 x 45cm. 'I was working on my large Adam and Eve and I was trying to find a "look" for Eve – reflecting her act?' Photo by Simon Olley

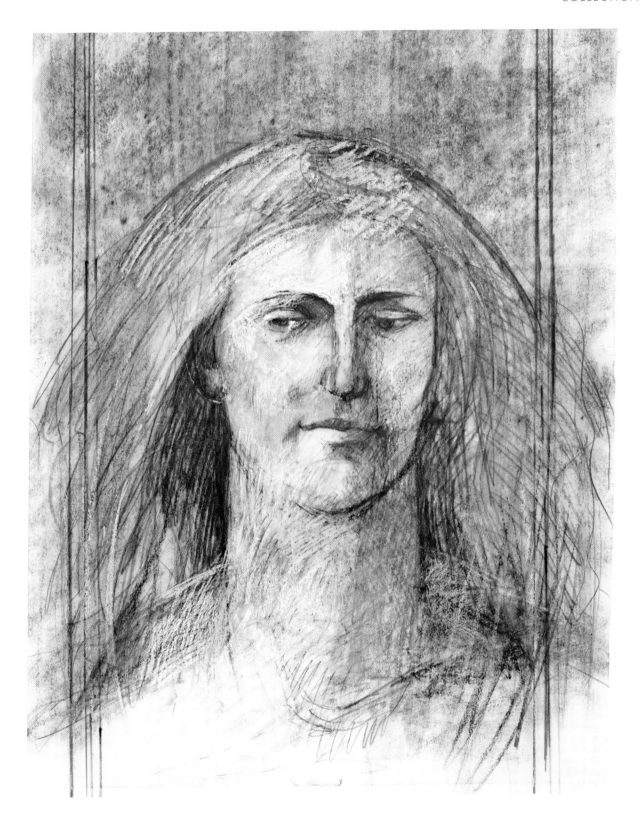

11

CV & Gallery

Artist Statement

Designer/maker of wall panels, hangings, pictures, carpets, screens and altar frontals. Work is mainly to commission and produced in all types of cloth and yarn. Individuality of design stemming from a fine art training in drawing and painting. Versatility of subject spanning the figurative, descriptive and representational to the abstract and conceptual, thus always reflecting the donor/client source and site.

Qualifications

1968 Diploma in History of Art, University of London
1963 City and Guilds of London Institute, Embroidery
1961 Art Teachers' Certificate, Goldsmiths' College
1960 National Diploma in Design (Painting), Goldsmiths' College School of Art

Professional Societies

1987-90 Chair and Fellow of the Society of Designer Craftsmen
1984 Elected Fellow of the Royal Society for the Arts
1978-85 Chair and Emeritus Member of the Embroiderers' Guild

Teaching

1999 Artist in Residence, Kingshill Festival, Kent
1982/85 Lectures and workshops to accompany the British embroidery exhibitions to Tokyo and Osaka
1982 Lecture tour, USA and Canada
1980 to present Freelance teacher and lecturer
1980 to present Panel Lecturer, Victoria and Albert Museum
1973-78 Lecture tour, USA and Canada
1968-80 External examiner, Universities of Bath and Birmingham
1968-80 Principal Lecturer and Head of Department of Fashion and Textiles, Stockwell College of Education, Bromley
1963-68 Lecturer, Fashion Department Maidstone College of Art
1961-63 Head of Art Department, West Heath School, Sevenoaks, Kent

Publications

2009 *An Embroiderer's Eye: the Diana Springall Collection*, Silk Heritage Trust, Macclesfield

RIGHT *Carpet*, Swaffham Norfolk, 1988-1991

Part of a Sanctuary project that also included the making of altar rail kneelers, choir seats and 3 sedilia cushions. Worked by a group of 45 people.

'The carpet is made of nine patterns repeated five times which were inspired by the floor designs and the shapes between the Butterworth rail. Each square is 30cm with a border of 2.5cm of black which is surrounded by 1.25cm of green and edged in 12.5cm of black. Velvet and tent stitches are used to form the relief which rises above the border. In making up the carpet an additional width of longitudinal green stripe was designed to relate to the altar table mullions.'

Wilton wool on a 10 hole to the inch canvas ground, 4 x 2.30m. Photo by Dave Hankey

2005 *Inspired to Stitch*, A&C Black, London

1988 *Design for Embroidery*, Pelham Books, London (p/b edition 2010)

1985 *Twelve British Embroiderers*, exhibition catalogue

1984 *Twelve British Embroiderers*, Gakken, Tokyo

1980 *Embroidery*, BBC, London

1969 *Canvas Embroidery*, Batsford, London

Commissions

2010 *Elmhurst*, private commission

2004 *Children of the World* Dossal hanging, St Nicolas Chapel, Shere Church, Guildford

2002-03 Seven panels, The Hospice in the Weald, Kent (designer, community project)

2002-03 Design for nine panels, St John the Baptist Church, Meopham, Kent

1999 Altar frontal, St Mary the Virgin Church, Riverhead (community project)

1997-99 Panel, Dunsfold Church, Surrey (Designer/tutor, Millennium Lottery Funded community project)

1997 *Exodus 25*, two hangings, West Central Synagogue, London

1993-97 Carpet, St Mary's Church, Kemsing (Designer/tutor, community project)

1995 Torah covers, Liberal Jewish Synagogue, London

1992 Two altar frontals, RAF Cranwell, Lincolnshire

1991 Pat Coen memorial panel, Logica London Office

1988-90 Sanctuary Scheme (carpets, kneelers, cushions) Swaffham Church, Norfolk

1989 *Alpha/Omega*, double sided panel, St Anne & All Saints Church, London

1989 Carpet, Dai-Ichi Kangyo Bank, London

1989 *Rising Sun* panel, Dai-Ichi Kangyo Bank, London

1988 *Graduands* panel, University of Sheffield Library

1988 *Beryl A Oil Field* panel, Mobile North Sea, London

1982 *Book of Kells* panel, private commission

1975-84 Kneelers and altar cushions, St Anne's Chapel, Lincoln Cathedral

1975-80 *Chester Today*, five panels, Chester Town Hall (Designer/tutor, community project)

1975 *Jessica*, Cherry Garden School, Bermondsey, London

1974 *White Horse of Kent*, commission for Kent Education Committee

1972 Trinity altar frontal, Farningham Church

Public and Private Collections

Embroiderers' Guild

Kent Education Committee

Victoria and Albert Museum

Numerous private collections worldwide

Exhibitions

2009/10 *4th European Quilt Triennial*

2009 *An Embroiderers' Eye: The Diana Springall Collection*, Macclesfield Silk Museum

2005 *Inspired to Stitch*, Knitting and Stitching Show: London, Dublin, Harrogate (curator)

1998 *Journey to Embroidery*, Sevenoaks Library (solo),

1996 *Corporate Projects*, Coutts Bank, The Strand, London (solo)

1990 *British Ecclesiastical Embroidery Today*, St Paul's Cathedral, London

1988 Smiths Gallery, Covent Garden, London (solo)

1985 Society of Designer Craftsmen

1985 *Twelve British Embroiderers*, Osaka and Tokyo (artist and curator)

1982 British embroidery exhibition, Osaka and Tokyo (curator)

1981 Foyles Art Gallery, London (solo)

1980 *Embroiderers' Guild Exhibition*, Commonwealth Institute, London

1976 *The Makers*, Victoria and Albert Museum

1966 *Embroiderers' Guild Diamond Jubilee Exhibition*, Commonwealth Institute, London

Prizes/Awards

1999 Nomination, first Creative Britons Award
1995 South East Arts award to attend European Textile Network conference, Russia
1994 SE Arts award, research Arraiolos carpets of Portugal
1994 South East Arts to attend European Textile Network conference, Hungary
1985 Nomination, first annual Worshipful Company of Broderers Prize

Advisory/Honorary Roles

2006 Honorary Member, 62 Group of Textile Artists
1991-2006 Fabric Advisory Committee, Guildford Cathedral

Reviews and Articles

Maggie Grey, *World of Embroidery*, July 1999 pp223-225
Roderick Cooper, *Kent Life*, October 1997, p41
Ian MacPherson, 'The Chester Embroideries', *Madeira Newsletter*, Autumn 1992
Claire Melhuish, 'Applique Approach', *Church Building*, Autumn 1989, p31
Bonnie Arakie, 'Portrait of an Artist', *Interior Design Handbook*, 1989 p148-151
Trevor Gett, 'Selling from West to East', *International Textiles Interiors*, 1988 p72
Kate Southworth, Corporate Commissions, *Officespec*, 1988, p106-7
Elizabeth Benn, 'Diana Springall: a profile', *Embroidery*, 1984, p54-54

Jessica, 1983

Cherry Garden School for the Mentally & Physically Handicapped, Bermondsey, London

Machine appliqué of furnishing fabrics, 1 x 1.6m. Photo by John Hunnex

Detail right. Photo by Diana Springall

OVERLEAF *Winter View of Faro*
Gouache painting. Photo by Simon Olley

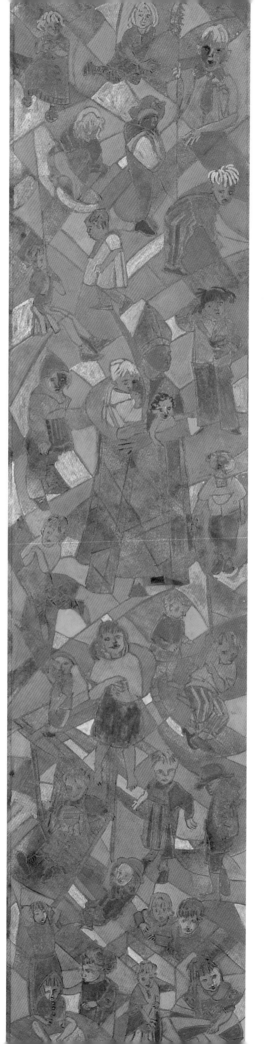

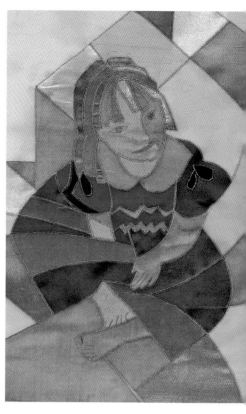

Children of The World 2004

Dossal hanging, St Nicolas Chapel in the Church of St James, Shere, Surrey. 600 x 130 cm

FAR LEFT Ink drawings in preparation for for *Children of the World*

LEFT Gouache design for *Children of the World*

ABOVE Detail of the machine appliqué on metallic organza

Photos by Simon Olley

RIGHT *Children of The World* in situ.
Photo by Joe Low

Design for Advent Altar Frontal, St Mary the Virgin, Riverhead, Sevenoaks, Kent, 1999

The design had to take account of the rich figurative and highly decorated reredos with adjacent tiled walls and patterned floor and have regard for the need for the embroidery to be shared imperceptibly amongst a group of about twenty stitchers. 105 x 287cm

LEFT Detail of one of the embroidered squares on the superfrontal

Canvas embroidery in cotton perlé in size 3 and 5 on a 12 hole canvas 15.5cm.
Blue linen textured in self colour pulled work in perlé cotton

Photos by Diana Springall

Slippers, 1998. Photos by Diana Springall

TOP, LEFT TO RIGHT Gouache design for the right foot references the CBE; Gouache design for the left foot denoting symbols of an engineer; Completed embroidery for slippers right foot before making up

BOTTOM, LEFT TO RIGHT Embroidery in progress for left foot; Finished slippers. Tent stitch in Medici wool on a canvas ground. Designed to celebrate the 75th birthday of David Piésold: a civil engineer honoured with the CBE – note each foot is different–

From My Window Sill, 2008
Silk patchwork hanging 2.3m x 1.76m
Detail above
Photos by John Elliot

OVERLEAF
PAGE 162 *Pot on My Window Sill*
Gouache painting. Photo by
Simon Olley

PAGE 163 *Pear Trees in Winter*
Gouache painting. Photo by
Simon Olley

Kneelers and altar cushions, St Anne's Chapel, Lincoln Cathedral 1975-84

ABOVE LEFT TO RIGHT
Stained glass window, Lincoln Cathedral
Detail of canvas embroidery

LEFT Completed kneeler showing embroidery set into scarlet cowhide

FACING PAGE Gouache designs

'[The embroidery] had to be hard wearing and technically simple enough for a group to embroider from the simple paintings, samples and basic instructions provided. Durable but fine Wilton carpet thrums were worked on a twelve hole to the inch canvas (2.5cm). The main body of the hassock was made in cowhide to limit the amount of fine work. It was also the practical solution to the problem of everyday wear and tear.' (Design for Embroidery, 1988)

'The most important factor in this church project was that the chosen design should relate to its environment which was historic and timeless. The kneelers had to blend and belong and yet become the jewels in an already ornate setting. The paintings were made after first studying the pattern already existing in the thirteen century stonework within St Anne's Chapel. They were also strongly influenced by the dominant feature of the Chapel: the stained glass roundels within the slender fenestration. Finding the patterns and choosing the colours was fairly easy and reflected what was already present. The final design solution took shape by reiterating the dominance of the circular window motifs together with their existing scarlet and blue.' (Design for Embroidery, 1988)

Photos by Diana Springall

Snow on the Kemsing Hills
Gouache painting. Photo by Simon Olley

PAGES 166-167 *Horses*. Photo by Simon Olley

RIGHT *Violas for Chelsea* (turquoise), 2000
Photo by Simon Olley

OVERLEAF
Elmhurst detail. Photo by Simon Olley

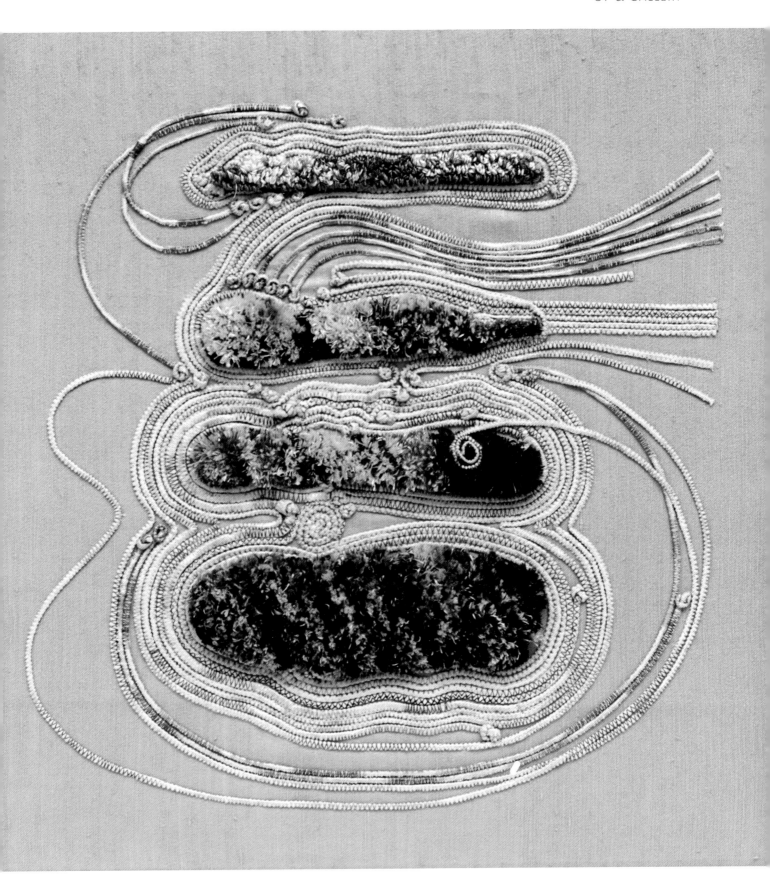

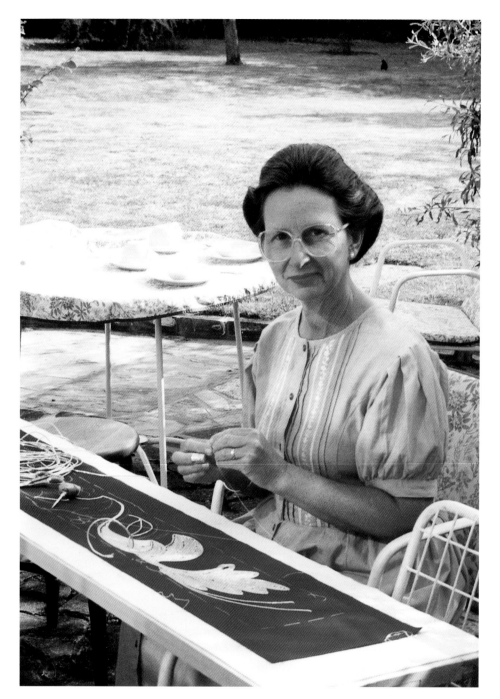

RIGHT *Altar Frontal Memorial Chapel RAF College Cranwell,* 1992

Gold cord couched onto a silk brocade ground. Photo by Dave Hankey

Diana working on the RAF Superfrontal, 1992. Photo by Dave Hankey

BELOW Pencil sketch made on site of the delicate carved wooden frame of dossal frame, Memorial Chapel RAF College Chapel Cranwell, 1992

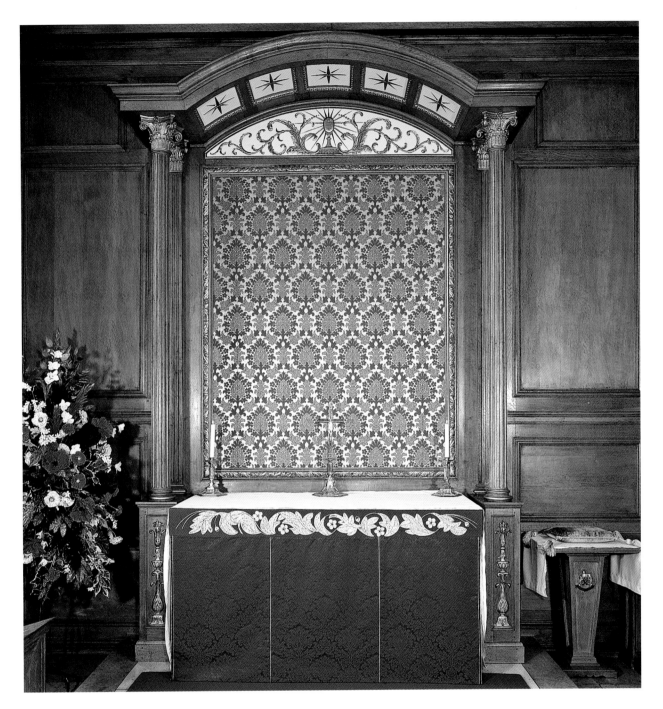

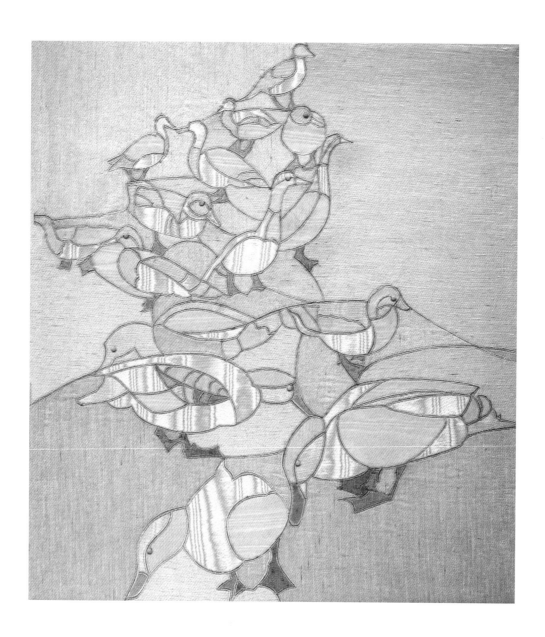

Ducks 2000

Machine appliqué panel. Fabrics include dupions, moiré
satin, gros-grain satin on vilkene ground, beads. 67 x
60cm. Made for the artist's granddaughter Hannah.
Photo by James Morton-Robertson

Index